The Art of Private Devotion: Retablo Painting of Mexico

Corrigenda

The Art of Private Devotion: Retablo Painting of Mexico

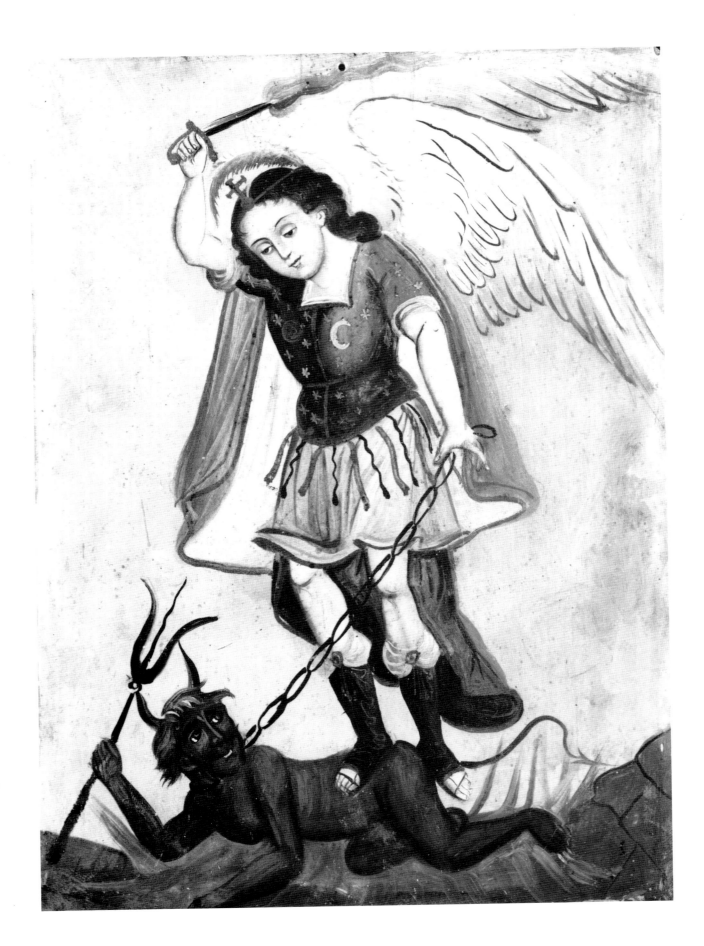

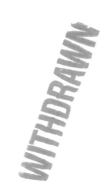

The Art of Private Devotion:
Retablo Painting of Mexico

Principal essay and catalogue by
Gloria Fraser Giffords
with accompanying essays by
Yvonne Lange
Virginia Armella de Aspe and Mercedes Meade

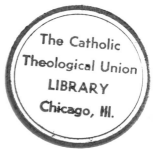

InterCultura, Fort Worth
and
The Meadows Museum, Southern Methodist University, Dallas

The Art of Private Devotion: Retablo Painting of Mexico

Published in conjunction with an exhibition of the same title shown at the following museums:

The Meadows Museum, Southern Methodist University, Dallas, Texas
Field Museum of Natural History, Chicago, Illinois
The Mexican Museum, San Francisco, California
The Spencer Museum of Art, Lawrence, Kansas

Initial funding for this project was provided by the Lende Foundation. The exhibition was supported in part by a grant from the National Endowment for the Arts, a federal agency. The exhibition symposium, held in Dallas, was supported in part by a grant from the National Endowment for the Humanities.

Library of Congress Card Number 91-70111
ISBN no. 0-935937-10-2
Printed in U.S.A.

Distributed by the University of Texas Press

Design: James A. Ledbetter
Editor: Elizabeth Mills
Photography: Michael Bodycomb, except for nos. 21 and 63
Typesetting: G&S Typesetters, Inc.
Printed and bound by: Hurst Printing Company

InterCultura
3327 West Seventh Street
Fort Worth, Texas 76107

The Meadows Museum
Meadows School of the Arts
Southern Methodist University
Dallas, Texas 75275-0356

Cover:

Our Lady of San Juan de los Lagos
Nuestra Señora de San Juan de los Lagos
Private Collection
Catalogue Number 34

Frontispiece:

Saint Michael the Archangel
San Miguel, Arcangel
Private Collection
Catalogue Number 65

Contents

Lenders to the Exhibition

Bill Adams, Conyers, Georgia
Ray and Sarah Balinskas, Houston, Texas
Calderela Antiques, Jack Calderela, El Paso, Texas
Mr. and Mrs. Charles Campbell, San Francisco, California
Graciela Cantu, Mexico City, Mexico
Frank Carroll, Houston, Texas
Margaret A. Clark, San Francisco, California
Tonia and Bob Clark, Houston, Texas
Roy Dowell, Los Angeles, California
Martha Egan, Albuquerque, New Mexico
Doug and Rhonda Forsha, Scottsdale, Arizona
Mr. and Mrs. Graham Gray, Houston, Texas
Nancy Hamilton, El Paso, Texas
Sallie Griffis Helms, Houston, Texas
Loretta Russell Hoffmann, Houston, Texas
Janis and Robert Keller, El Paso, Texas
Barbara and Justin Kerr, New York, New York
Mary and Bob Koenig, Chicago, Illinois
Henry C. Lockett, III, Sodona, Arizona
The Mexican Museum, San Francisco, California
Pamela Pettis Mitchell, Santa Fe, New Mexico
Joe and Rae Neumen, Redlands, California
Ray Pearson, El Paso, Texas
Mr. and Mrs. Joseph P. Peters, Philadelphia, Pennsylvania
Lari Pittman, Los Angeles, California
Kurt Stephen, McAllen, Texas
Tiqua Gallery, Santa Fe, New Mexico
Mr. and Mrs. Francis E. Tolland, El Paso, Texas
Ron and Chris Tracy, Chicago, Illinois
Richard Worthen Galleries, Albuquerque, New Mexico
Mr. and Mrs. Bartell Zachry, San Antonio, Texas
Private Collections: Dallas, Los Angeles, Tucson

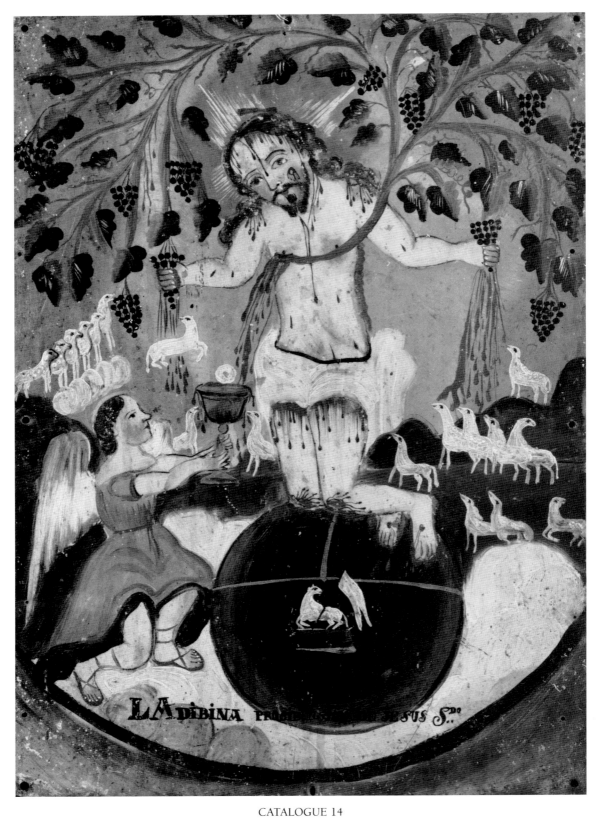

CATALOGUE 14

THE EUCHARISTIC MAN OF SORROWS /

EL HOMBRE EUCARISTICO DE DOLORES O EL VARÓN EUCHARISTICO DE DELORES

KURT STEPHEN

Foreword

Mexico is a country whose artistic and cultural traditions are as diverse as they are rich. Inter-Cultura has been fortunate enough to work extensively in the field of Mexican art over the past several years, and it is with great pleasure that InterCultura and the Meadows Museum of Southern Methodist University, Dallas, Texas, co-publish this book on the occasion of an exhibition of Mexican folk *retablo* painting.

The current exhibition grew out of a suggestion from Barbara Kerr in 1987. Barbara and Justin Kerr are renowned photographers, collectors, and conservators of pre-Columbian and Latin American art, and lenders to the exhibition. While reviewing her collection of *retablos,* Barbara observed to me that there had never been a major exhibition of Mexican *retablo* painting in the United States, and on this basis InterCultura embarked on organizing such an exhibition.

The result is *The Art of Private Devotion: Retablo Painting of Mexico,* which, for the first time in the United States, offers to the public a significant exhibition of *retablos.* This book provides an accompanying in-depth study of the tradition by several of the most important scholars in the field.

These vigorous expressions of popular belief proclaimed the spirit of freedom and self-determination resulting from the independence of Mexico from Spain in 1821, and became one of the most important forms of indigenous expression in Mexico in the nineteenth and early twentieth centuries. Their seeming naïveté belies the sophistication of *retablo* painting: numerous international and Mexican styles were brought together in subtle ways to respond to the popular need for an intimate and accessible expression of the deep spirituality of the Mexican people. *Retablo* painting possesses both an integrity and a straightforward manner of expression that was later considered to be of major importance by many of Mexico's influential early twentieth-century artists, including Diego Rivera, Frida Kahlo, and Roberto Montenegro. This rich and fascinating artistic tradition represents an important cultural link between Mexico and the United States.

It has been a privilege to collaborate with Southern Methodist University's Meadows Museum, its director, Donald E. Knaub, his staff, and the dean of the Meadows School of the Arts, Eugene Bonelli, in the realization of this project. Nicole Holland, formerly executive vice president of InterCultura, and her team did a superlative job during the long process of organizing the exhibition. The show would have been impossible without the generous support of its underwriters: the National Endowment for the Arts, and the Lende Foundation of San Antonio, which provided seed money for the project.

We are grateful to the lenders to the exhibition and to its funders for a unique opportunity to enhance cultural understanding between Mexico and the United States, and to deepen our appreciation of the artistic achievements of our good neighbors to the south.

Gordon Dee Smith
President
InterCultura

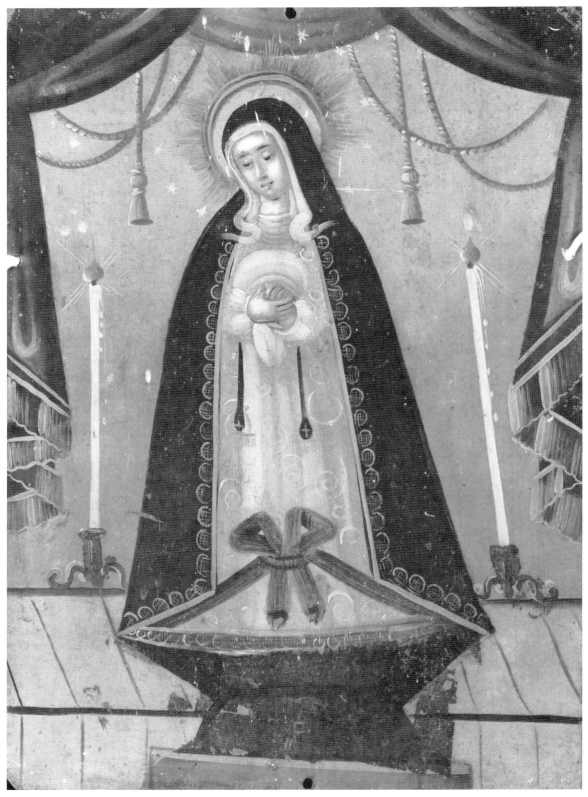

CATALOGUE 27
The Lady of Solitude / La Soledad
CALDERELA ANTIQUES, JACK CALDERELA

Introduction

Among the many decorative objects North Americans have discovered from our neighboring culture to the south are the small paintings on tin called *retablos*. Originally these small paintings were not intended as decoration but for use in a home altar, a format foreign to North American culture with its more institutionalized religions.

The term *retablo* at first seems a misnomer in the world of art history, where we associate *retablo* painting with large-scale church altars rather than small devotional paintings. The Meadows Museum is fortunate to have in its collection several more formal examples from the fifteenth- to seventeenth-century Spain. Because the intellectual trail of images used in Mexico *retablo* painting follows from continental Spanish culture, and the means of transmission is not always fondly remembered, there is a certain irony in the Meadows Museum hosting this first exploration of Mexican *retablos* as a legitimate art form.

We ask you as a viewer to bring a sense of openness to this new arena of study. We have assembled an important and representative group of Mexican *retablos*, but we recognize that this is just a beginning. We sincerely hope that the exhibition will lay a foundation for future study of these devotional objects. More important, however, we hope this exhibition will help bring North Americans a greater understanding of our neighbors in Mexico.

On behalf of the Meadows Museum I wish to thank InterCultura and its principals, Gordon Dee Smith and Nicole Holland, for their cooperation in organizing this important exhibition. Special thanks to the lenders of Mexican *retablos* for their willingness to part with the objects for this touring exhibition.

Donald E. Knaub
Director
Meadows Museum

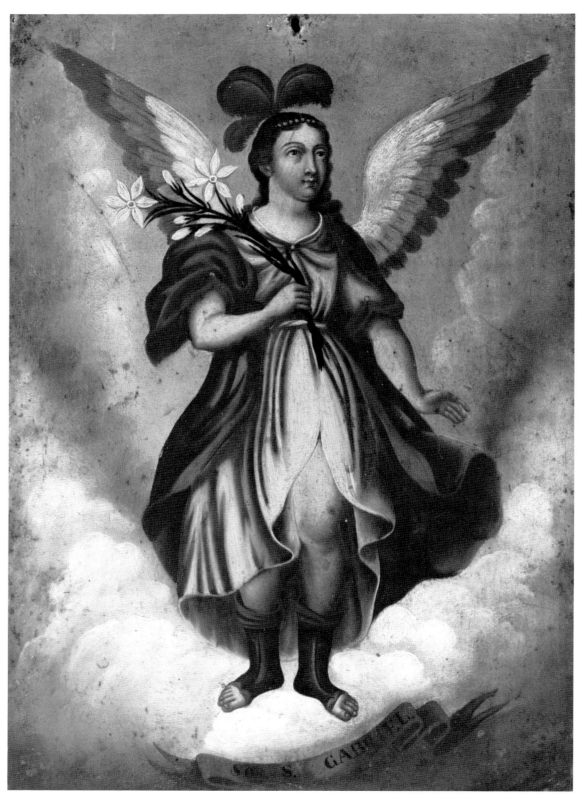

CATALOGUE 49
Saint Gabriel the Archangel / San Gabriel, Arcangel
BILL ADAMS

Preface and Acknowledgments

The opportunity offered by the study of *retablo* painting of late nineteenth- and early twentieth-century Mexico is thrilling, unlocking a vast panorama of historical and cultural influences and counter-influences that historically have informed the shaping of a great state. The footprints of the several nations that have passed through the country of Mexico and left their mark, alongside those of pre-existing indigenous cultures, is manifest in these captivating and intimate objects. The charming and powerful devotional images that constitute *retablo* painting form together an important branch of that unique tree of Mexican art called *artes populares,* the arts that encompass aspects of both the fine and the folk arts.

We thank Gloria Fraser Giffords, the leading expert in the connoisseurship and conservation of *retablo* painting in the United States of America, for serving as curator, as well as principal catalogue essayist, for this exhibition, *The Art of Private Devotion: Retablo Painting of Mexico.* The grant awarded to the project from the National Endowment for the Arts, as well as funding provided from the Lende Foundation, have enabled Ms. Giffords to travel extensively throughout the United States and Mexico, to inspect scores of collections, both private and public, in preparing the object list for the exhibition.

Ms. Giffords' selection offers a unique opportunity to examine the aesthetic and historical principles underlying these works and the criteria that characterize their finest flowering. Furthermore, her identification of specific artistic hands—the Dyslexic Painter and the Red Bole Painter, to name two—constitutes a giant step in the sorting out of individual artistic personalities, providing ground for future research and connoisseurship. The catalogue published for the exhibition will provide a valuable tool for collectors and connoisseurs, and is the only English-language publication on the subject currently available.

We are grateful, as well, to the contributing essayists, Dr. Yvonne Lange, director emeritus of the International Museum of Folk Art, Santa Fe, New Mexico, for sharing her exciting research concerning iconographic sources of *retablo* imagery in European printmaking; and to Dr. Virginia Armella de Aspe and Mercedes Meade, advisors to the Pinacoteca Virreinal, Mexico City for their essay on European antecedents of Mexican religious painting. The dialogue initiated by these essay contributions will serve to generate debate, discussion, and scholarship.

Elizabeth Mills, associate editor, the Southwest Review, edited the catalogue essays with painstaking care and professionalism. Betty Wiesley, professor of Spanish, Southern Methodist University, translated the essay by Virginia Armella de Aspe and Mercedes Meade. We thank Michael Bodycomb, staff photographer of the Kimbell Art Museum, for his excellent work in preparing the illustrations. James A. Ledbetter produced the catalogue design with his customary informed good taste.

Eric Davis, registrar, the Meadows Museum, and Peggy Booher, exhibitions coordinator, InterCultura, executed the duties of exhibition consolidation with finely honed professionalism. Anne Henderson, former curator of education, the Meadows Museum, organized the exhibition symposium in Dallas, which received a National Endowment for the Humanities grant. Anthony Foster, exhibition designer, created the exhibition installation.

Our gratitude extends, as well, to Sue Devine, director of development, the Meadows School of the Arts, and Gordon Dee Smith, president, InterCultura, for their efforts in ensuring

the realization of the project, with the support of Lori Al-Aqqad, executive assistant, Inter-Cultura. Leigh Kauffman, Ann Hefner, and Beth Wareham, former staff members of Inter-Cultura, were instrumental at the inception of the project, as was James Bradburne, former director of design, InterCultura, who provided the initial concept for the design program of the exhibition. We have enjoyed our efficient and stimulating collaboration with Donald E. Knaub, director of the Meadows Museum, and his assistant, Marilyn Spencer.

Finally, we are deeply appreciative to the lenders who have entrusted their objects to the exhibition, without whom, of course, the project would not have been possible.

We trust that audiences in Dallas, Chicago, San Francisco, Lawrence, Kansas and beyond will exult in the experience offered here to examine in depth, breadth, seriousness, and delight the artistic manifestation of a key spiritual and cultural tradition.

Nicole M. Holland
Executive Vice President
InterCultura

Curator's Preface and Acknowledgments

Since the publication of my book, *Mexican Folk Retablos* (University of Arizona Press, 1974), two important things have occurred in collecting *retablos*. There has been a gradual but dramatic increase in the prices of the paintings, and the difference between prices in the country of source, Mexico, and the United States, the largest market area, has diminished. At first the increase was not caused by shortages, but rather, it seems, by the publication of this book legitimating the subject. *Retablos* became *objets d'art* worthy of museum space and even of philosophical ponderings on their ethno-historical significance and their influence on modern artists. Also, partially because of this new awareness created by the book, the United States market became more widespread, with dealers using published material to create an interest in the paintings and collectors searching for specific themes or stylistic categories that were mentioned in the literature.

This catalogue is written for individuals who have been studying and collecting *retablos* for some time, who are familiar with the first book, and who would enjoy additional information, written and illustrative; as well as for the student/collector who is just becoming ensnared by their charm. Some terminology and information have been repeated for the latter, but there is sufficient new material here to help broaden the veteran's understanding.

I have maintained a passionate interest in *retablos*, continuing to examine and analyze them stylistically and iconographically. Although it would be difficult to say how many I have seen in the past sixteen years, in selecting pieces for this exhibition I examined over ten thousand *retablos* in the past three years, from one hundred private and museum collections, and I photographed over eight hundred more.

In my continuing research into Christian iconography and the effects of imported symbols on popular arts and crafts, popular religious beliefs, demographic distributions, and so on, I have been forced to re-think conclusions, make iconographical corrections, and clarify stylistic influences, as well as broaden my views of religious folk art in general. Some things that now seem so obvious and logical were not even considered until others generously pointed the way. I am enormously grateful to these individuals and wish to acknowledge their contributions. Graciela Cantú, Doctor Ruth Lechaga and Señora Teresa de Pomar were gracious enough to spend time with me in Mexico City, explaining their collections. Francis and Luz Tolland's experience and diligence in the subject made them invaluable sources. Earnest Martin selflessly opened his files to me. Importantly, both Ernie and Fran put me in contact with other dealers and collectors. I have kept a file of letters from Nancy Hamilton, *retablo* devotee for years, in which she shares her experiences in collecting, her reasons for selecting certain themes, the prices paid, and, very important, her own research concerning the D. A. Painter.

Yvonne Lange, director emeritus of the Museum of International Folk Art, not only prevented me from committing heresies in iconographical and Catholic dogma (during a marathon working weekend at her home in July 1990, ecclesiastical fine points rained down upon me), but furnished copies of her own research on influences in popular religious art. Elizabeth Lonergan, world traveler and literary critic, and Frederico McAnish, scholar, historian, and lay priest, graciously read the manuscript, correcting and making valuable suggestions. The collectors and curators are to be given special thanks for their time and their willingness to share not

only their collections but their expertise, with me and with the reader.

My husband, Spencer Giffords, was as enthusiastic about the project as I and provided not only physical and moral support, but helped keep me focused on certain directions in the selection process. Finally, I'd like to acknowledge the support and encouragement of my mother, Thora Ackard Clifton, to whom this is lovingly dedicated.

Gloria Fraser Giffords

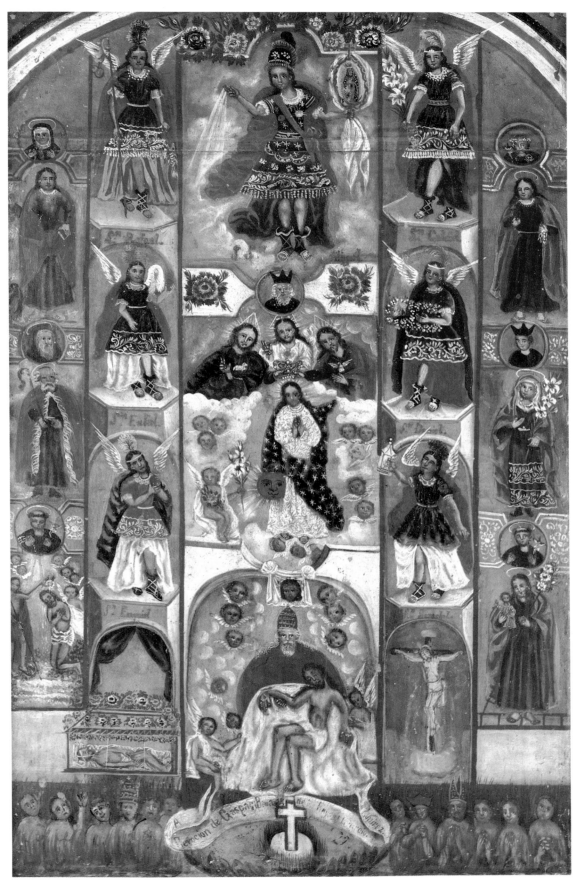

PLATE I CATALOGUE 1

ALTARPIECE / UN RETABLO

HENRY C. LOCKETT, III

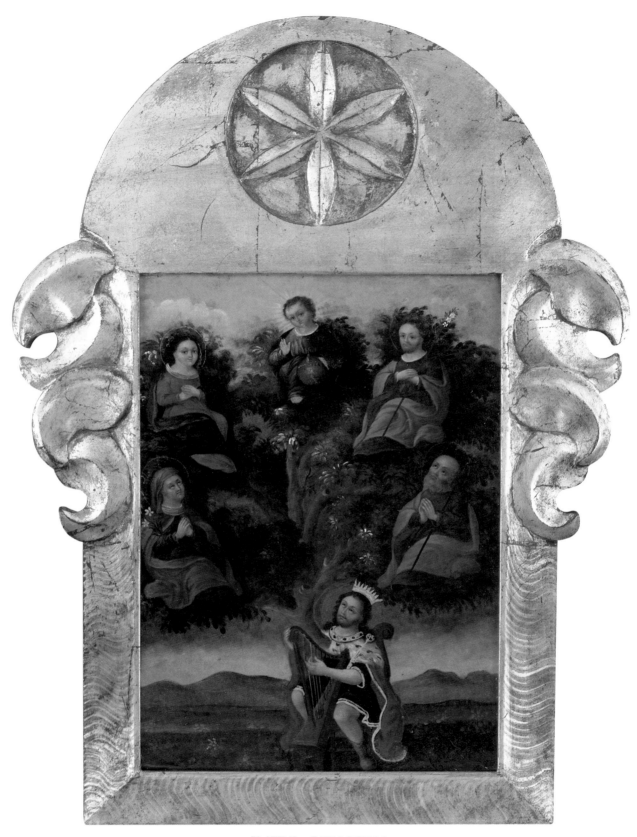

PLATE II CATALOGUE 2
The Tree of David / El Arbol de Dávid or La Parentela de Jesús
PRIVATE COLLECTION

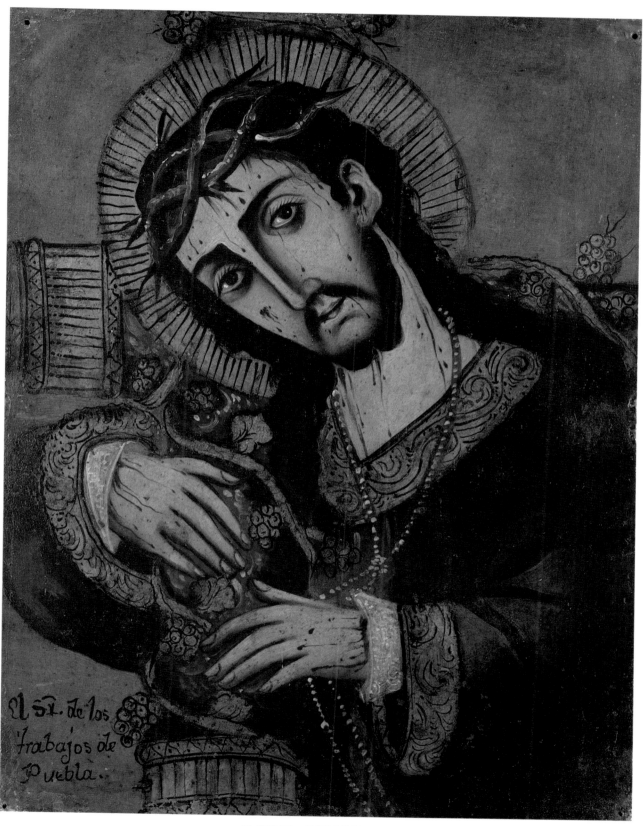

El Sr. de los Trabajos de Puebla.

PLATE III CATALOGUE 15
THE LORD OF LABORS OF PUEBLA / EL SEÑOR DE LOS TRABAJOS DE PUEBLA
PRIVATE COLLECTION

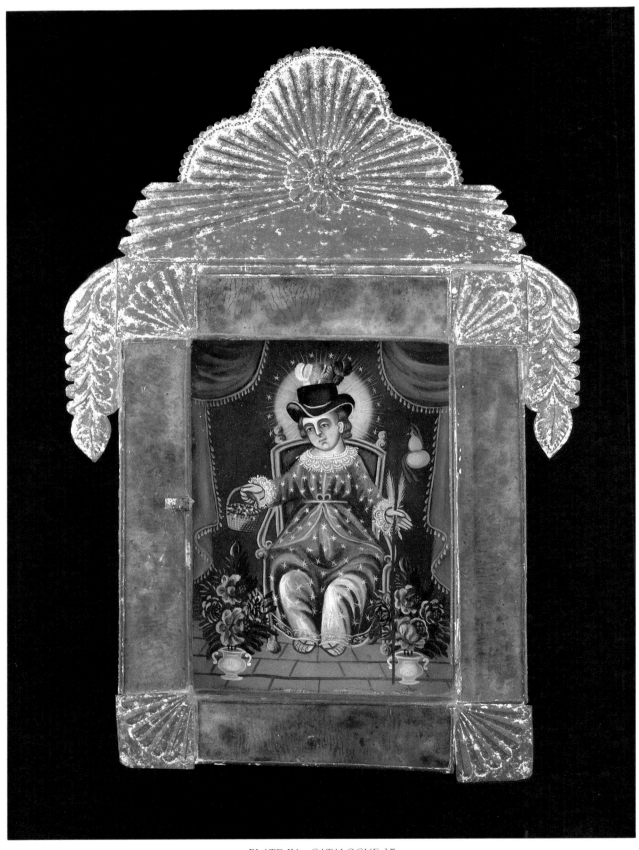

PLATE IV CATALOGUE 17
THE CHILD OF ATOCHA / EL NIÑO DE ATOCHA
PRIVATE COLLECTION

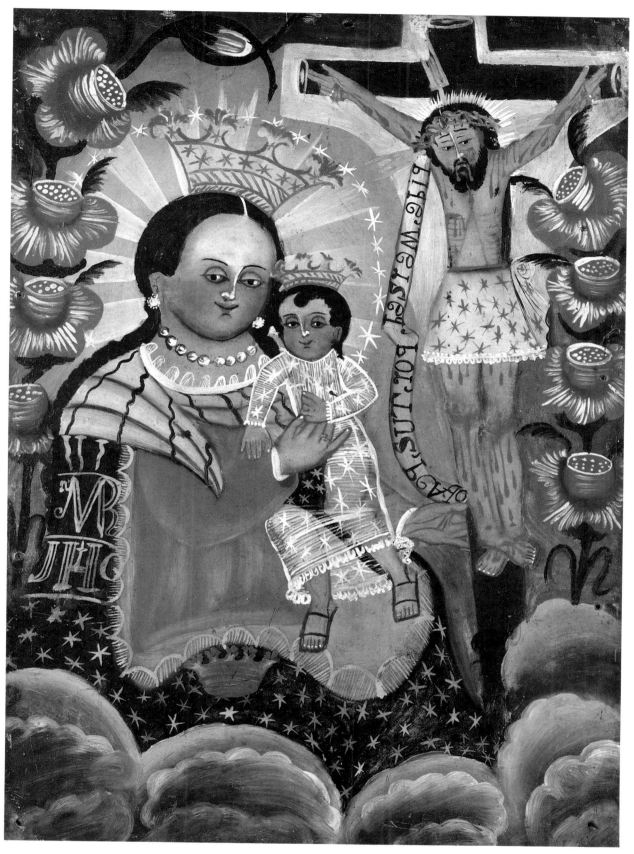

PLATE V CATALOGUE 23
OUR LADY, REFUGE OF SINNERS / NUESTRA SEÑORA, REFUGIO DE LOS PECADORES
PRIVATE COLLECTION

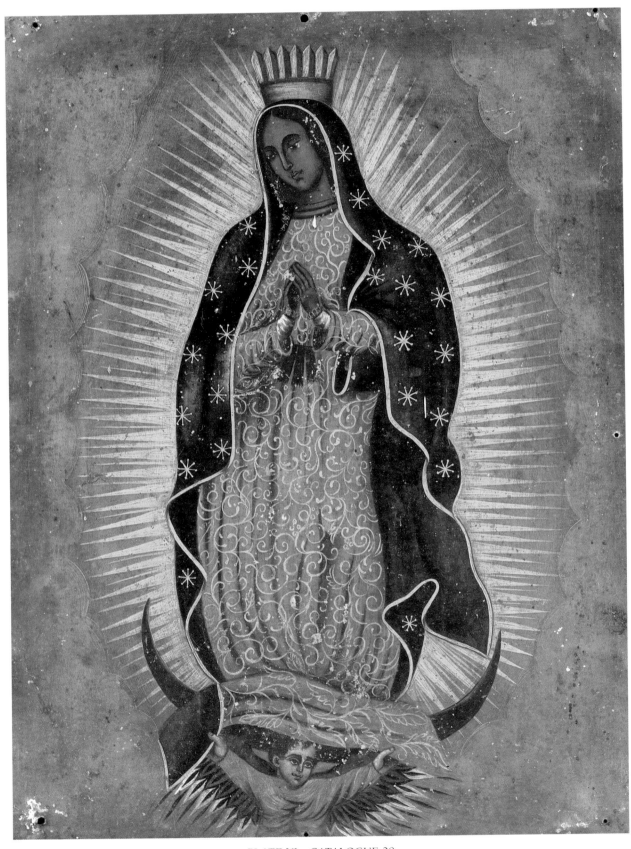

PLATE VI CATALOGUE 29

OUR LADY OF GUADALUPE / NUESTRA SEÑORA DE GUADALUPE

ROY DOWELL/LARI PITTMAN

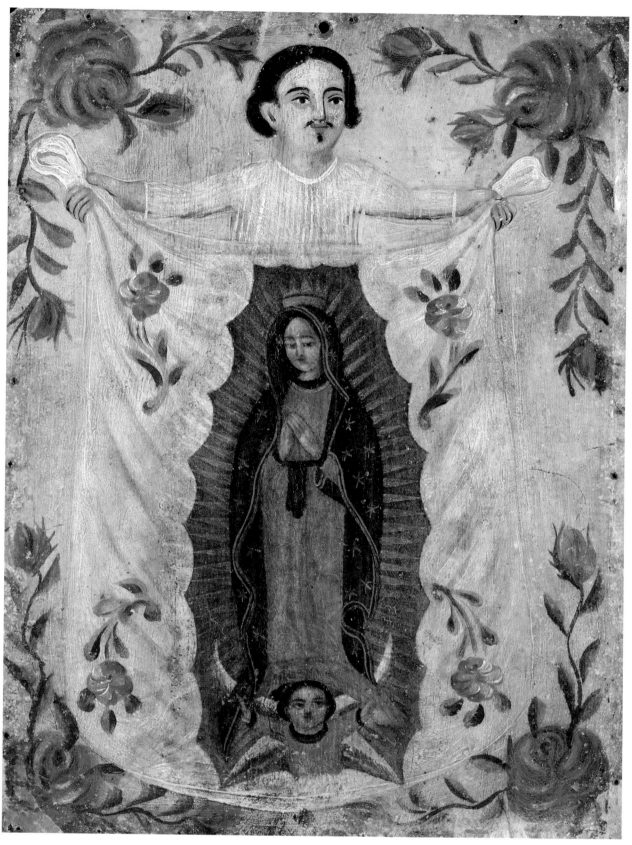

PLATE VII CATALOGUE 30
JUAN DIEGO WITH THE *TILMA* OF THE VIRGIN OF GUADALUPE /
JUAN DIEGO CON LA TILMA DE LA GUADALUPANA
PRIVATE COLLECTION

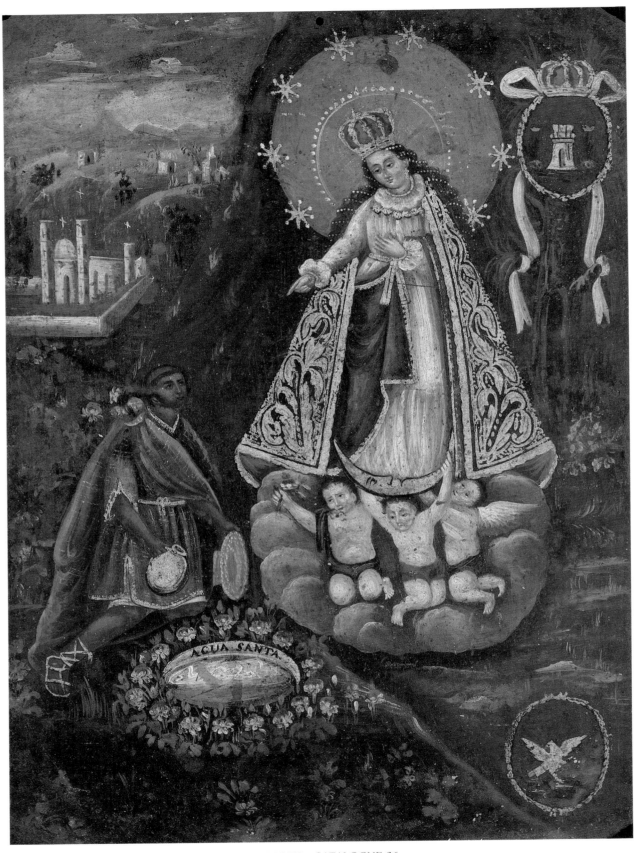

PLATE VIII CATALOGUE 36
Our Lady of Ocotlan / Nuestra Señora de Ocotlán
GRACIELA CANTU

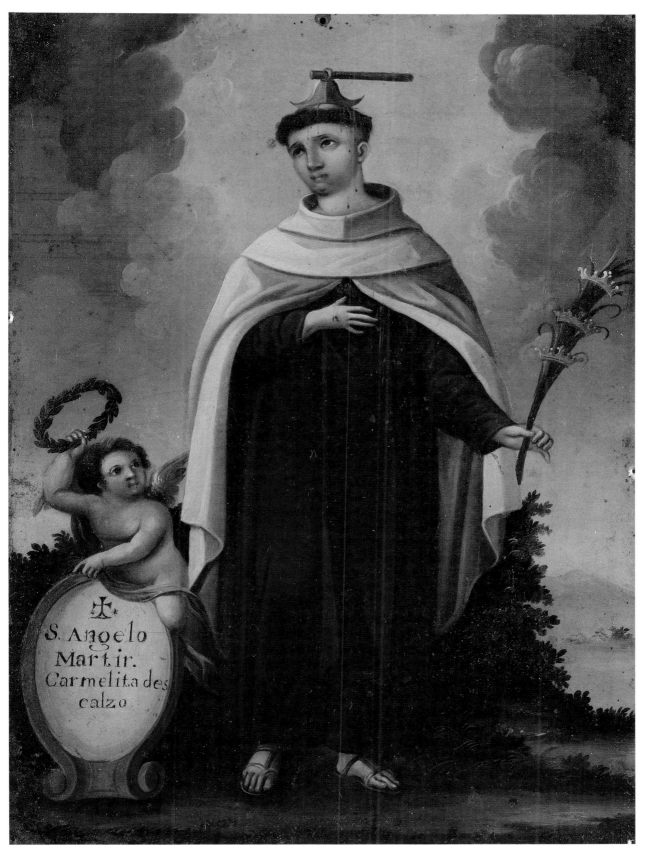

PLATE IX CATALOGUE 41
SAINT ANGELUS THE MARTYR / SAN ANGELO, MARTÍR
PRIVATE COLLECTION

PLATE X CATALOGUE 44
SAINT BENEDICT OF PALERMO / SAN BENITO DE PALERMO
THE MEXICAN MUSEUM, SAN FRANCISCO

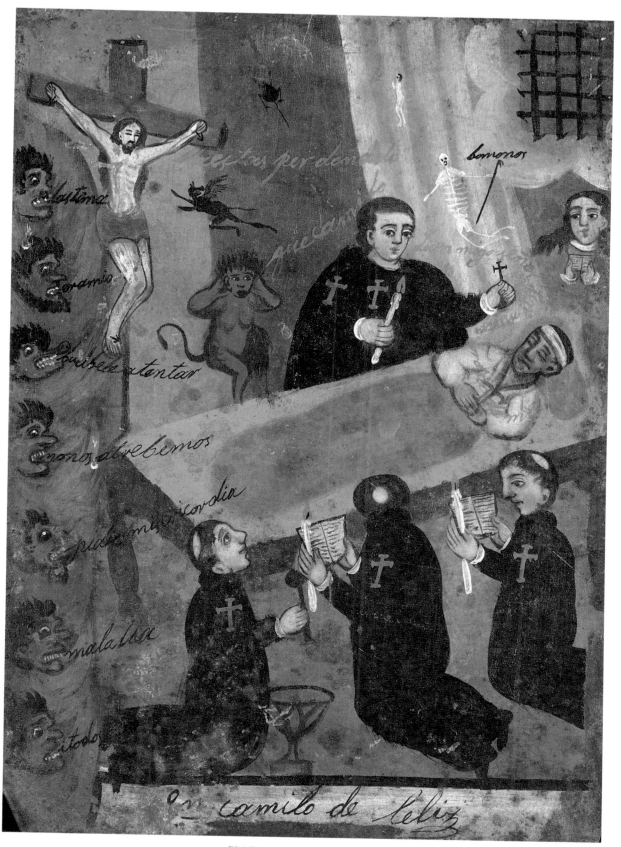

PLATE XI CATALOGUE 46
Saint Camillus of Lelis / San Camillo de Lelis
Barbara and Justin Kerr

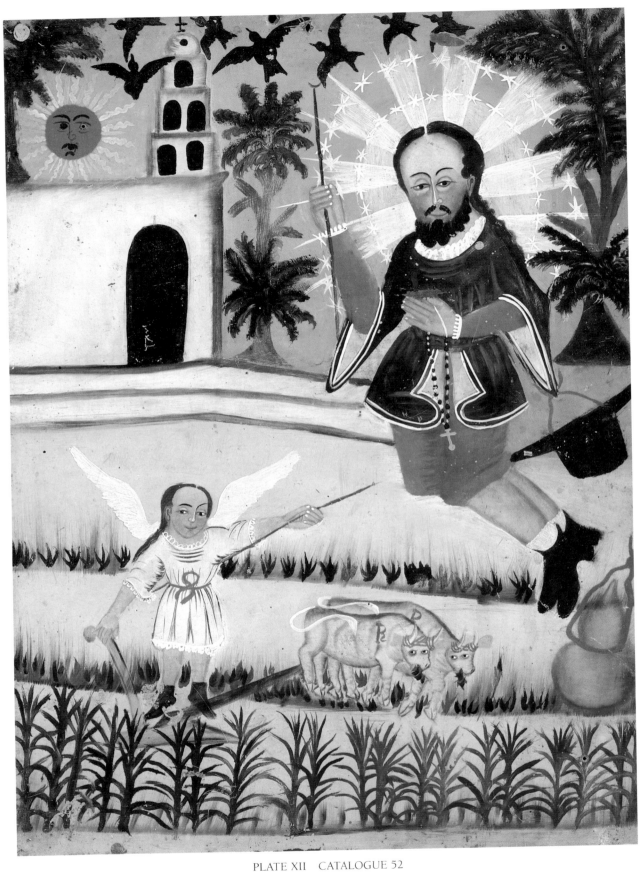

PLATE XII CATALOGUE 52
Saint Isidor the Laborer / San Isidro, Labrador
Nancy Hamilton

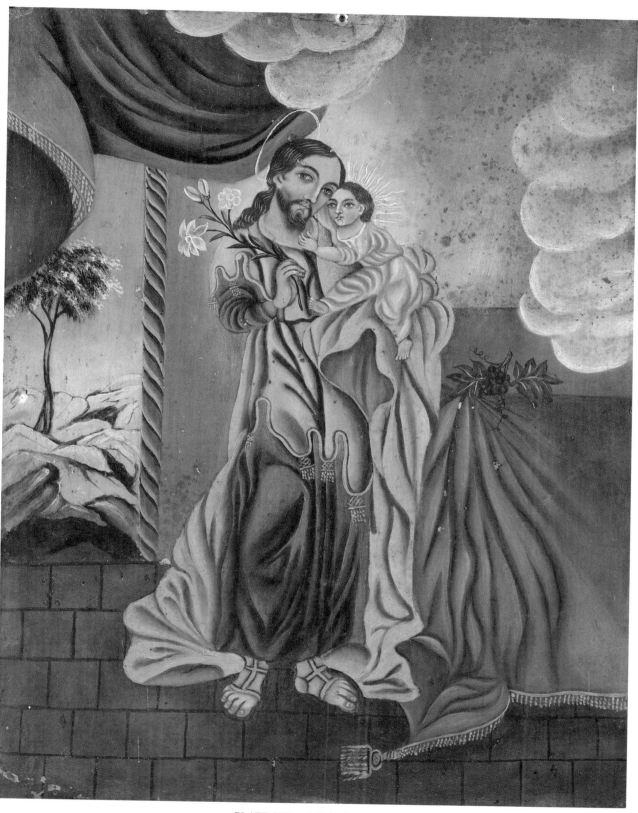

PLATE XIII CATALOGUE 59
S<small>AINT</small> J<small>OSEPH</small> / S<small>AN</small> J<small>OSÉ</small>
J<small>OE AND</small> R<small>AE</small> N<small>EUMEN</small>

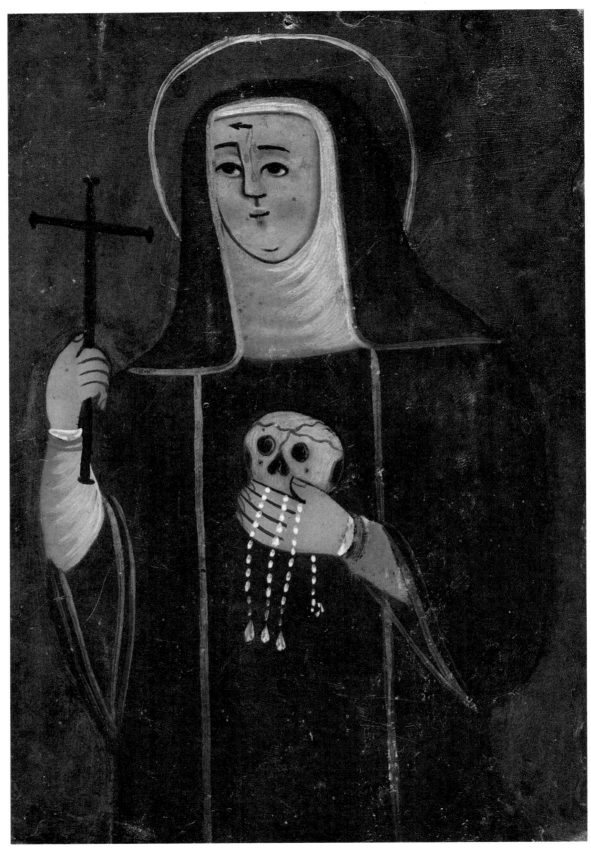

PLATE XIV CATALOGUE 71
Saint Rita of Cascia / Santa Rita de Cascia
Pamela Pettis Mitchell

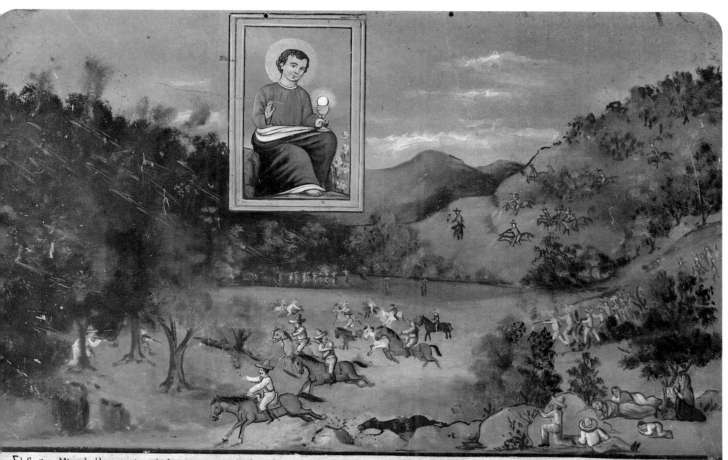

El Señor Miguel Hernandes á qien reconocian los suyos como General, rompio el citio que le pucieron sus cantrarios á el y sus sol—
dados, en un mal pais que se llama Yopecuaro, abiendose visto en peligro de morir el y sus soldados pero fiado en Dios se arrojó
á salirse entre el tiroteo por todos lados. Pero en ese momento de tanto riesgo, Aclamio al Santo Niño Salvador. y la Señorita Juanita
Estrada con la mamá el papá unos niños y otras personas que á corta distancia bieron dicho acontecimiento ofrecieron un
retablo si los faborecia, y fue oida su peticion porque milagrosamente se salvaron todos sin lamentar ninguna desgracia personal
solo un caballo perdido. En accion de gracias publican el milagro por medio del precente. hoy 5. de Enero de 1920.

PLATE XV CATALOGUE 83

EX-VOTO, 1920

CALDERELA ANTIQUES, JACK CALDERELA

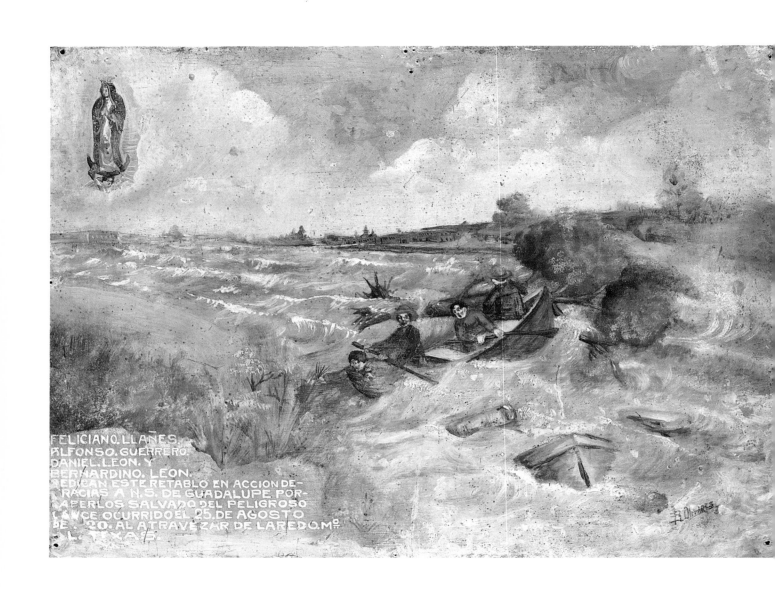

The text within the painting reads:

FELICIANO. LLAÑES.
ALFONSO. GUERRERO.
DANIEL. LEON. Y
BERNARDINO. LEON.
DEDICAN ESTE RETABLO EN ACCION DE-
GRACIAS A N.S. DE GUADALUPE POR-
HABERLOS SALVADO DEL PELIGROSO
LANCE OCURRIDO EL 25. DE AGOSTO
DE. '20. AL ATRAVEZAR DE LAREDO. M°
-L. TEXAS.

PLATE XVI CATALOGUE 84
EX-VOTO, 1920
RON AND CHRIS TRACY

The Art of
Private Devotion:
Retablo Painting
of Mexico

Gloria Fraser Giffords

The terms *retablos, santos sobre hoja de lata,* and *láminas* all describe a particular type of Mexican religious art that dates from the early nineteenth through the early twentieth centuries. These are images of a single saint or groups of holy personages painted in oil on pieces of tin-plated iron. Anonymous artists produced thousands of these paintings in styles and techniques ranging from the naïve to the academic.

Retablos can also be used to describe paintings of thanks, *ex-votos,* or *milagros* (miracles), which depict events where individuals dedicating the paintings are assisted through divine intervention. The terminology becomes more tangled because *milagros* can refer to almost any object used as testimony to divine assistance, including cut or cast metal replicas of body parts; discarded crutches, casts, and braces; locks of hair; and, within the last forty years or so, x-ray plates, photographs, and hospital identification bracelets.

Because *retablos* can be used in either sense, in a context where there might be confusion the terms *retablo santo* and *retablo ex-voto* are used to distinguish between the two types. The terms *milagro* and *ex-voto* will be reserved for the votive paintings.[1]

The *láminas,* or *retablos santos,* were intended for private devotion, however, and their production ceased around the turn of the century. The *retablo ex-voto* or the *milagro,* including the painted variety, continue to be produced as gifts to a particular divinity or divine object, and they are often seen hung or pinned on or near them in the shrines throughout Mexico.

Descriptions of paintings on tin in the literature of the late 1800s through the 1950s refer only to *ex-votos,*[2] which for the most part were called *retablos* by donors and by the artists.[3] The word *retablo,* however, was used in the United States to describe small New Mexican religious paintings on wooden tablets (*tablas*).[4]

The word *retablo* derives from the Latin *retro tabula,* behind the (altar) table. Strictly speaking, *retablo* (retable or altarpiece) defines the decorative and didactic paintings and sculp-

ture behind the altar table. Although the origins of the art form are obscure, we can trace them to the early Christian reliquary boxes that were placed at the rear of the altar and, later, to the twelfth- and thirteenth-century painted altar frontals and apse murals of Spain.[5] The frontals and the apse murals contained depictions of an enthroned Christ or of the Virgin, with side panels filled with images of the saints or events in their lives. Architectural influences contributed to the evolution of the *retablo* in Spain. The progression from the unbroken wall spaces of the Romanesque to the Gothic with its ribs and windows greatly reduced the amount of wall space available for ecclesiastic painting. Beginning as a backdrop to the Mass, the *retablo* assumed an overwhelming size and opulence, with some Spanish examples as tall as fifty feet. With Spain's conquests in the New World, this artistic tradition was imported to the colonies along with the Catholic religion.

The Baroque style and the Counter-Reformation closely expressed the spirit of discovery and the spiritual and military conquest of Mexico. The wealth of the new lands and the fervor of converting hundreds of thousands of natives influenced not only the forms and sizes but also the contents of Mexican religious structures. While most sixteenth-century churches were single-naved, in keeping with the austere monastic structures favored by the Mendicants, beginning around the seventeenth century church apses and transepts became filled with carved and gilded architectural confections. The ornate structures framed, supported, and displayed paintings and realistically carved, painted, and sometimes fully clothed religious figures that illustrated the lives of the saints and were intended to teach dogma and reaffirm one's belief.

Several other factors contributed to the proliferation of *retablos*. New churches were established, populations increased, and financial support for additional altars flowed in from the *confradías* (brotherhoods) and *gremios* (guilds). The abundance of mineral wealth in some places as well as the popularity of certain religious figures and their cults was such that some churches might be described as "gilded canyons." During this time the *retablo* form was extruded to the façades of churches. *Retablos exteriores* not only held religious statuary and formed a background for staging ceremonies, but they also gave a preview of what might be found inside.[6]

From this elaborate, well-structured accompaniment to the religious edifices, embodying Catholic dogma and the Counter-Reformational spirit, the term *retablo* became attached to a single painting, perhaps by association with the votive painting. Possibly because of the similarity of size and material the term *retablo* also became attached to the popular paintings of saints on tin.

Religious Imagery

In Central Mexico the Spaniards found highly organized and skilled artistic traditions among groups of native artisans working in a wide range of media. These artisans quickly were utilized and under the friars' direction schools were established to teach European methods in arts and crafts.[7] Soon Mexico developed not only its own artistic traditions, but, as the colonization and

so-called civilization process continued, a new race and ethnic identity—the mestizo, a mixture of Spanish and American Indian ancestry.[8] Gradually Mexico's artistic dependence on Spain diminished, and new forms and new solutions to architectural and artistic problems were generated by individuals bred, born, and trained in Mexico. The marriage of the two civilizations would produce a subtle, almost subliminal artistic sensibility, also called mestizo, that persists today.

Religious imagery always serves as an aid to worship. Dogma and beliefs as well as a religious identity are imparted to the congregation through this imagery. In the Catholic Church the religious imagery was especially important to set forth the hierarchy of the religious personages as well as show veneration towards Christ and the saints. Well aware that new converts might transfer their affections to the images themselves, the Spanish friars nevertheless encouraged devotion to them in order to strengthen the converts' ties to the church and weaken their attachment to pagan beliefs.

Seeking a state of *tabula rasa,* the Spaniards destroyed the native religious images and structures, either by superimposing one of their own or by incorporating a building's structure into the new edifice.[9] The difficulty of transferring beliefs from one cult to another was partially circumvented by incorporating certain native traditions, and the process was aided by the similarities in the protective and restorative benefits of certain images.[10] Transplanted on Mexican soil, therefore, for the next three hundred years, were images and symbolisms that had antecedents in European pagan beliefs and in certain Near East traditions. Medieval beliefs, Renaissance rationale, and the frenzy of the Baroque became subtly intertwined and made fertile ground for the formation of a new culture and new art forms.

The need for religious imagery in the earliest years first was met by paintings, prints, and sculpture imported from Spain and then gradually replaced by works produced in Mexico. Guild ordinances give us some idea of the range of colonial crafts, the hierarchy in the various workshops, the training requirements for painters and sculptors, and restrictions against specific racial groups.[11] Attempts to regulate production and control the artisans indicate that there was enough activity outside the guilds to cause official concern. Correct interpretation of religious figures was a matter of interest not only to the guilds, but also to the Office of the Inquisition.[12]

Although we do not know how many works of art were produced and who owned them,[13] each dwelling could be counted on to contain some token. Without abundant samples the predominant kinds of popular religious imagery during the first three centuries can only be surmised. There is little left to guide us, but what remains suggests that inexpensive black and white prints, small carved and painted statues, and small paintings on wood and canvas were owned by most ordinary people. Canvas and wood are easily affected by moisture, however, and preventive measures rarely were taken. Paints were likely to peel or crumble away and insects to consume entire panels and canvas supports, and the images were simply replaced with new ones. In the very act of devotion, sometimes touching or handling also can create

damage. The heat and smoke from votive candles have spelled the end to many a good painting or sculpture.

Materials and Techniques

Mexico wrested independence from Spain in 1821. Although it may not have been perceived at the lowest levels, the social and economic atmosphere was changing. The liberal movement within the church at this time was followed not too many years later, in 1859, by Benito Juárez's Laws of Reform, which significantly altered the church's role in Mexico. Formal separation of church and state, confiscation of church property, the establishment of civil marriage, a more modern economy, secular graveyards, secular education, and the expansion of an infrastructure were the products of this new and emerging system, which had important effects upon Mexicans, individually and as a nation.

In most countries political freedom and social release have engendered popular artistic expressions. In Mexico there also was an upswelling of craft industries. This is not to discount the one hundred years or more of brutal peonage and social injustice that would pass—interspersed by a war against foreign intervention and a revolution—until issues of equality and political participation would be addressed. But with independence came a shift towards a national identity and a renewed vitality. Opportunity and the need to produce goods locally created a yeasty atmosphere that, combined with a revivified Mexican artistic energy, helped create the folk *retablo*.

Independence had eliminated the Spanish trade monopoly. Mexico could now import materials from other countries. Trade protection favoring Spain was abolished, and certain industries previously reserved for Spanish ownership were released. The appearance of raw materials and finished goods from the United States and Europe increased dramatically.

In the early eighteenth century metallurgical processes had developed to a high enough degree for production in quantity of an inexpensive tin-coated iron sheet. Developed originally for its smooth, rust-proof surface, the material was used in a number of ways. It could be cut, bent, and soldered to form vessels for preserving foods—that is, the tin can. Among hundreds of other items manufactured were plates, stoves, buckets, cups, boxes, candle holders, lamps, and frames. Whereas tinned iron leaves commonly were used for inexpensive utilitarian objects in Europe and America, tin as a surface for painting religious subjects appears to be almost exclusively Mexican.[14]

It is difficult to make even a moderately intelligent guess as to how many *retablos* and *exvotos* were painted, based upon what remain in private collections, museums, and churches. Because of the ephemeral quality of inexpensive goods produced for everyday, domestic use, it is impossible to learn from existing evidence how much imported tinned sheet was consumed in the manufacture of household goods, compared with its use as a painting surface.

One hears from dealers and collectors that *retablos* were painted on discarded oil or food containers, and this is clearly evident on some pieces from the creases and embossing in the tin.

The word *lata* (tin can) is sometimes used to refer to the *retablo,* as in *santos sobre hoja de lata* (saints painted on tin cans).[15] However, in comparing *retablos* (their gauges of metal and the manner in which it was cut, and the way in which the tin was applied) with objects of definite tin can ancestry—with New Mexican tinwork of the same era—there are enough differences to indicate that the greatest majority of *retablos* were painted on the same material used to manufacture household items.

Tin had been found and processed in Mexico prior to the Spaniards' arrival.[16] Tin was gathered from alluvial deposits along the sides of gullies and washes, and during colonial times the production of tin became a small-scale industry. Tin's greatest use was initially in the production of bronze for bells and military and industrial apparata, although Barrett states that some tinned goods such as plates and candleholders were produced in small quantities. Fray Francisco Atanasio Domínguez's inventories of missions in 1779 also record the presence of a number of pieces.[17] The demand for tin, although small, was of crucial importance, and its extraction and founding were a constant problem to colonial officials because the Spanish crown controlled the price and market, and the area of greatest abundance, Mesa del Salitre, was located in the hostile Indian area of Durango.

Tinplate, however, came exclusively from foreign sources. Tin had been mined continuously in Cornwall, England from about 500 B.C. Although quantities fluctuated depending upon the more accessible supplies in Brittany and northern Spain, when these deposits petered out beginning in the twelfth century the demand for English tin steadily increased. Methods for hand-making (pounding and dipping) tinned iron sheets were in use at least by the early twelfth century, but tin-plating was a minor industry until new technological processes were developed almost six hundred years later. By 1730 machine-rolled tinplates were being produced at Pontypool, revolutionizing the process.

Although not enough research is available at this time to determine exactly which pieces or what percentage of tinned sheets used for *retablos* are from other sources, we know they were not Mexican because tinplate manufacturing did not begin there until 1947. The direct source of the manufactured sheets was not Spain either, as her industry did not begin until 1892. Furthermore, it was not until the late 1800s that the United States began to compete in foreign tin markets. Because of the efficiency, good prices, and increases in production, it is probable that the greatest source for tin-plated sheets was England. The only niggling fact is that the areas where most *retablos* appear to have been produced are not too distant from colonial tin sources.[18]

The tinned sheet provided a durable and pleasing surface on which to paint. In a moderately low humidity iron will not rust, and with the protective tin coating and painted surface the object is fairly stable. The natural processes of corrosion and oxidation can destroy these works, but generally speaking oil paint and tin made a good partnership.[19]

Sizes for the *láminas* follow an approximate formula, give or take a quarter of an inch. The smallest are generally 2½″ x 3½″ and the next size is double, or 3½″ x 5″. The doubling con-

tinues until the largest size, 14″ x 20″, is reached. The largest and smallest sized *láminas* are the rarest, with the middle sizes, 7″ x 10″ and 10″ x 14″, being the most popular.[20] (Many *ex-votos* also appear in these sizes, as well as in 5″ x 7″.) Custom partially may have decided the popularity of sizes. Large sizes were more difficult to transport, for example, and therefore not used by itinerant artists. By the third quarter of the nineteenth century, terne plate (a lead-tin alloy on iron or steel sheet, 15 percent tin and 85 percent lead) became available in sizes up to 40″ x 28″.[21]

Size also played a role in shaping the artistic qualities of the *retablo santo*. The pieces 5″ x 7″ and smaller have a better sense of composition and their designs seem to be more controlled and compact. Neither the artists nor their methods are known, but it would seem that the small paintings would have been hand-held or propped on a knee, close enough that the entire format could be viewed. Without having to move the eyes even slightly, the entire field would be visible and a homogenous design could evolve. This theory is borne out by a comparison between paintings of different sizes having the same theme and done by the same hand. The larger ones do not have the balance and control of the smaller pieces. My experience with projecting slides of small *retablos santos*, say 3½″ x 5″, to a much larger format, measuring even in feet, is that the images still have compositional merit. On the other hand, reducing a 14″ x 20″ image rarely improves the piece; a weak design is a weak design. This fault might have been improved if the artists had painted at a distance from the *retablo,* enabling them to see the entire format at once.

The paints used for *láminas* and *ex-votos* were similar to those found in traditional nineteenth- and early twentieth-century oil paintings on canvas. The surface occasionally is given a priming coat to help the paint adhere better and, possibly, help prevent rusting of the underlayers. One group of painters in particular favored a dark reddish-brown paint as a primer.[22] One artist used blue. Unfortunately, the backs of the tin sheets were rarely treated and some have rusted and pitted badly.

Artists occasionally drew their figures first in pencil, and in some cases the oil paints have become transparent with age and these lines now are obvious. The transparency also allows the priming, especially the red, to glow through, giving the painting a much darker shade than originally intended and creating unintended contrasts between opaque and less opaque pigments. The reflective nature of the metallic surface helps create an effect in older, more thinly painted pieces that makes the *retablo* unique and the object identifiable at a distance.

Sometimes a *lámina* is found on which another, entirely different, image has been painted. The original painting has become visible with time or an impasto can be detected in raking light that outlines or defines some underlying figure. These overpainted pieces are not the results of inept restoration efforts, but rather, competently done paintings. A reasonable assumption is that through acts of devotion the *láminas* became worn or otherwise bedraggled and were repainted. This is not at all uncommon with Greek and Russian icons, for example. Careful separation processes of the various layers during the conservation of icons has demonstrated that the same image had been reapplied, sometimes a century later. In these cases the magic that a piece has acquired through belief and emotional investment is preserved and possibly strength-

ened. Sometimes, however, in Mexican *retablos,* the images beneath are radically different from those on top. Some examples are Santa Heduvige painted over La Trinidad, San Francisco de Paola obscuring Santa María, and San Luis Gonzaga sharing the same face as San Vicente Ferrer, though the latter's wings are beginning to show in the background and his Dominican habit can be picked out under the Jesuit saint's ruffled alb. The newest image was always painted in the same direction as the older, however, for whatever reason. Some other theory besides piety must be devised for the recycled *láminas.* One may be simply the shortage of materials, the artist reusing a piece of metal taken in trade or purchased as scrap. Or perhaps someone wanted an image that was not in stock and the client's needs were obliged by painting his favorite over another representation.

Dates

Whereas the *ex-votos* usually were dated, the *láminas,* for the most part, were not. One notable exception, the D. A. Painter, in addition to supplying his initials kindly dated his works, which enables us to attach rough dates to his years of production (Nos. 7 and 25 are other exceptions).

How does one date a *retablo santo* then, if there are no dates on them or *ex-votos* by the same hand with which to compare? One can make a fair judgment by examining the reverse side (if rust has not completely removed it) for unevenness or a dark coloration that often characterizes the early pieces. This method is not exact enough, however, without comparing various types of tin for age or country of origin. But there appears to be a correlation among *retablos* having extremely shiny, smooth backs, images with distinctly Victorian color combinations and decorative devices, cults that were introduced to Mexico around the end of the century (such as the Our Lady of Lourdes and Our Lady of La Salette), and pieces that were produced in a very rapid and cursory manner. Although these combinations appear in small proportion to the overall *lámina* production, the shiny surface seems to be the result of improved tinplating at the end of the nineteenth century, assuming the images are contemporaneous to the tin, and it would seem that the quality of some *retablos santos* have deteriorated either because of the lack of interest on the part of the buying public or the attrition of the earlier painters. A gradual lessening in quality of craftsmanship and lack of ingenuity is evident in *ex-votos* from the same time forward.

Using the dated votive paintings on tin, which begin around the 1820s, and comparing their colors, techniques, and styles—and assuming the same artists would have produced both genres—we can place *lámina* production from the 1820s to the early 1920s, with some of the finest, most imaginative work having been produced from the 1850s through the end of the century. In support of this theory we have: historical information on the availability of the tin-plated sheet; comparisons in deterioration between the *lámina* and the dated *ex-voto;* approximate dates for the appearance of certain cults, figures, and stylistic influences in Mexico; and the few *láminas* that were dated.

Areas of Production

The areas of greatest production of the *retablo santo* were the north central Mexican states, specifically the important religious and economic centers. The farming and mining districts around Zacatecas, fanning northward to Durango, Torreon, and Saltillo, southwest to Guadalajara and the Bajío east to Querétaro, and north again to San Luis Potosí produced the greatest numbers. Thousands have been gathered from these areas by peddlers in the last thirty years.

Some *láminas* were also produced south of the Bajío for example the images of Nuestra Señora de Ocotlán, in the state of Tlaxcala, and El Señor de los Trabajos de Puebla (the Lord of Hardships of Puebla, Nos. 36 and 15). (Note also No. 10, done by the same artist as No. 15.) All three works, interestingly enough, have in common the application of a metallic paint to garments and other details. Because of the fewness of pieces definitely known to have originated in these areas, it is impossible to arrive at any firm conclusions concerning quality. Those that have been collected there, however, tend to be of high technical quality. Perhaps the large and important city of Puebla and the close proximity to Mexico City afforded these artists more training. But considering the large population and wider availability of tinplate, why was the *lámina* not as popular in Puebla or Mexico City as it was in Northern Mexico? Were the people more sophisticated here, was canvas less expensive than tinplate, or was the *lámina* only a regional art form inspired by the appearance of tinplate and European lithographic images?

The lack of good roads and transportation during the nineteenth century greatly limited most people from casual travel beyond their villages. The resulting regionalism encouraged strong feelings of devotion to locally miraculous figures. The appearance is not coincidental, therefore, of a large number of *retablos santos* of figures such as N. S., Refugio de Pecadores (located at the Cathedral of Zacatecas, Nos. 22, 23, 24, 25), N. S. de la Luz (at the Cathedral of León, No. 28), and El Niño de Atocha (at Plateros, outside Fresnillo, Zacatecas, Nos. 17, 18, 19). The predominance of these particular figures in the region leads me to believe that this art form mostly was produced in these areas for local clients, or dispersed by trade or by pilgrims returning from these centers. El Niño de Atocha even exists in quantities comparing favorably with N. S. de Guadalupe, the acknowledged patroness of Mexico, who assumed nationalistic importance in Father Hidalgo's battle cry for independence. Also, there are an infinitely small number of *láminas* of other very important cult figures, N. S. de Remedios and N. S. de Ocotlán in particular, in the area of the Valley of Mexico and farther south. Religious articles probably were bought and sold in the nineteenth century just as they are one hundred years later, from artists or peddlers during important religious festivals, or they were purchased there and resold in shops near churches and shrines.

Inspiration

The *retablo santo* artist was a copyist, following centuries of tradition, and the principal sources of inspiration were two-dimensional engravings and lithographs of paintings and sculpture. En-

gravings and etchings imported from Spain, Flanders, Italy, and Germany since the early six-teenth century—themselves copies of important masters' works—have long been recognized as seminal in the creative process of the New World artist. The variety in images of the same figure and one's empathetic response to one over another might be explained in just how slavish or creative the artists were with their sources. Later, devotional prints imported from Swiss and French lithographic print houses began to serve as prototypes for Mexican religious imagery.[23]

In 1821, the year of the Mexican Independence, trade was established with the United States via the Santa Fe Trail, and caravans were launched west and ultimately south. Santa Fe, New Mexico was one destination for these religious images, but most likely not the final one. A tremendous amount of goods were transported from the eastern seaboard of the United States, carried by mule caravans or in enormous ox- or mule-drawn wagons into the north of Mexico over the Chihuahuan Trail, with as much as two-thirds of the original cargo intended for south-ern markets. Until 1882 trade was more or less frequent depending upon the political situations between the United States and Mexico. From Chihuahua City there were connecting roads to other points, but the most important, *El Camino Real* (the King's Highway), linked the north-ern provincial capitals of Durango, Zacatecas, Saltillo, and Monterrey, which were relatively isolated.

In 1882 the Atchison, Topeka, and Santa Fe railroad track was extended from Santo Do-mingo, New Mexico to El Paso, Texas, connecting with the just-opened Mexican Central. With the subsequent completion of the line to Mexico City by 1888, the Chihuahuan Trail ceased in importance, as did the Camino Real. The establishment of the railroads through this area co-incides with the production of a large number of *ex-votos*. The number of these *ex-votos* and the existence of *retablos* by the same artists strongly suggest the enormous effect of transportation capable of delivering heavy goods at a reduced rate.

Although we have no records to indicate the prices paid for *retablos*, it is certain the tin paint-ings would have been more expensive than paper prints. We know that ordinary citizens, how-ever, living in small towns, miners, merchants, and *campesinos* in ranching and farming com-munities, owned *retablos*, not just the upper classes.

Because of the scouring searches by *buscadores* (peddlers) for over thirty years, there is little opportunity today to find *retablos santos* in their original locale or ownership. Further-more, because the pieces range from seventy to one hundred and forty years in age, it is very unlikely one would meet an individual who purchased a piece from one of the original artists. Conversations in the field concerning original ownership are not very enlightening when one realizes that some pieces have had more than one owner. The cultural acceptance and domestic use of religious imagery among the owners has led to their general lack of interest in the crea-tive process and their selection rationale. We can only speculate on the purposes and creators of *retablos*, on the individuals who possessed them and the reasons their heirs have disposed of them.

The same factors that determine religious image selection today may well have been in effect a century ago. The greatest reason today for selecting a particular image is its alleged powers or the popularity of its cult. The immediate recognizability perhaps was another important influence on selecting a particular subject and technique.

Aesthetics

At the present time, tastes in Mexican religious art generally run to the colorful, polished, and sentimental. These criteria appear to have been in place a century ago, based on the evidence of the *retablos* and prints. Color was an important fact in the initial popularity of the *lámina,* considering there were no inexpensive colored items to replace them until later in the nineteenth century. During this period there were, of course, religious images painted on wood and canvas, with canvas possibly too high-priced for the popular artist and his clientele or too troublesome to transport. In addition to the colors, the durability, novelty, and the fact that the *lámina* incorporated the latest styles must have contributed to its attractiveness.

Stylistically, the paintings of the saints can be gathered into several loose categories depending upon the levels of artistic training and influences. Acknowledging an enormous debt to the importation of European sources, the works inspired by them may be broken down further into Baroque, Neo-Classic, and Romantic or Victorian styles. One category reflects the aesthetic tastes of the Italo-Byzantine and may be considered iconic. The Mestizo style, more difficult to pin down, is characterized by the tri-color sashes and birettas (No. 72), plumed helmets of warrior saints, the plumed hats of El Niño de Atocha, the sparse facial hair of Indian figures (Nos. 17, 18, and 30), and the bristling image of the dark skinned virgin, La Guadalupana. The mestizo Virgin is depicted with intense colors and patterns and suspended in space by an angel with tri-colored feathers. Her crown has even been changed into something resembling an Indian chieftain's headdress (No. 29).

Working in all the different styles were individuals who had some academic training in shading, perspective, and anatomy or who could be considered naïve or self-taught.

The Baroque sense of drama in color, lighting, and pose was absorbed wholeheartedly by the Mexican artist and never quite abandoned even through the period of Neo-Classicism. The sweetness introduced by the works of the seventeenth-century Sevillan, Bartolomé Murillo (1617–1682), and his followers, pervaded the culture. Sifted through less inspired hands during the next three centuries, this sweetness contributed to the cloying sentimentality of religious art in Mexico. Murillo's influence also may be seen in the figures he helped popularize: La Sagrada Familia (No. 6) and La Inmaculata. Another much rarer representation among the *láminas* is Christ, after the flagellation. Murillo painted two versions of this subject, which happen to be in American collections. The one displayed in the Krannert Art Museum at the University of Illinois could have directly inspired No. 9. The position of the short column of the flagellation with the flail, here a bundle of branches, and the position of Christ are remarkably similar.

Art of the late nineteenth century demonstrated an exaggerated emotional sensitivity that resulted in a general feminization of masculine figures. A tender softness is very evident in *retablo santo* art, particularly in male images associated with the Christ Child, such as San José and San Antonio de Padua.

When the Academy of San Carlos was established in Mexico City in 1785, Neo-Classicism formally was ushered in as the dictum of good taste. The exuberance and virility of the Baroque gradually had dissipated into frivolous excess, to be replaced by Neo-Classicism's cool refinement and Greek and Roman proportional ideals. The number of figures presented in the altarpieces were greatly reduced, thus limiting the overall size of the altar. The academic canons that would be imported from Europe over the next one hundred and twenty years, including those of the modern Germans of the Nazarene school, were taught rigidly at the academy and were insensitive and woefully out of touch with the Mexican spirit.

The Romantic realism popular in the Victorian era would officially and unofficially invade Mexico through the academy and through the inexpensive religious engravings. Colors were light and agreeable and their sentiments soft and appealing.

The imported religious prints injected the wild card of near-Eastern models. The so-called official art movement took no notice, the aesthetic probably being too remote or too exotic for their tastes. The subject matter certainly was out of the political mainstream. But the intense fervor portrayed by the brooding, iconic images of the Italo-Byzantine school struck a chord with artists who were catering to people far removed from academic tastes, whose taste in religious imagery required an immediacy, whose daily lives pulsated with otherworldly associations.

Subjects

In the last hundred years the Catholic Church has made a concerted effort to eliminate certain spurious saints and to concentrate on a few figures rather than an entire pantheon of holy personages.[24] A more sophisticated, mobile population has also contributed to the obscurity of certain saints.

Some saints and themes are overwhelmingly popular in *retablo santo* art. Marian figures, for example, account for about a third of the images produced. This number is heavily weighted by the enormously popular N. S., Refugio de Pecadores followed by the Mater Dolorosa and N. S. de Guadalupe. More male saints are represented because the Catholic Church has selected more males than females for canonization. In addition there are devotions that largely are not understood or appreciated today, such as the devotions of the Good Death and the Souls in Purgatory, and the related figures. San Francisco de Paola is an example of a protector figure surrounded, at one time, by a popular cult.

A farmer would pray to San Isidro (No. 52), for good weather and a good harvest. San Antonio de Padua (No. 43) was invoked for lost articles and for finding husbands for girls, while Santa Ana (No. 42) is looked upon as a model of motherhood because of the pious manner in which she raised the Virgin. Travelers and those inflicted with eye problems might pray

to the archangel San Rafael (No. 68), while one could count on San Blas for a remedy for throat ailments. One compelling reason to pray to the image of a particular saint was that one was named after him or born on his feast day. These figures would intercede in times of need.

Different parts of the lives or legends of a figure could be used for different reasons. San José, for example, is called upon for a "good" or "happy death" because legend says Christ and Mary were at his side when he died, besides his being a symbol of perfect fatherhood. Because of the gradual shift from a heavenly host to concentrate on only a few saints, certain images are considered responsible for handling a wide range of problems. The Virgin of Guadalupe, for instance, is invoked for any ill or misfortune. The same may be said for other figures of the Virgin and Christ. The charm and romance that associated heavenly beings with mundane earthly matters, which began in medieval Europe, has been winnowed in the formation of a more pragmatic religious organization.

Among my goals in choosing the examples of *láminas* in this exhibit was to present a wide range of aesthetic values and skills. It is important to see the overall variety done by hands that range from sophisticated to others that are almost childlike in their primitiveness. Focusing more narrowly, the variety within particular subjects such as La Trinidad, El Niño de Atocha, N. S., Refugio de Pecadores, and San José is thought provoking.

From the thousands of *láminas* examined, several exhibitions could have been mounted. An exhibition devoted entirely to Refugios or El Niños, all different yet alike, could be extraordinarily enlightening to both artists and folklorists. Historical pieces concerned with the lives of Christ or Mary suggest other themes, as do the members of the different religious orders. The themes of the *Ánima Sola* involving numerous characters and scenes of purgatory, and the saints involved with the cult of Good Death all could make up an exhibition showing the range of popular religious beliefs in the nineteenth century.

Particular styles and comparisons between them, such as the Neo-Classic or the Italo-Byzantine, could be another focus. A study of contemporary clothing and religious habits would interest some, while illustrations of tools, weapons, horse gear, and architectural details would thrill others.

The *ex-votos*, of course, deserve their own space and topics among them, besides clothing and furnishings, include social and class differences, political issues, and how people might view a historic event as opposed to a so-called official history.

The *retablos santos* are grouped here into four broad categories: Jesus, Mary, the archangels, and the saints. Historical and apocryphal figures are represented as well as those that serve as symbols in popular devotions, such as the *ánimas* figures.

Jesus

Scenes in *lámina* art of the historic life of Jesus are limited. Representations of his birth, the nativity, or the adoration of the shepherds and Magi are practically nonexistent, although infrequently we find a Flight into Egypt. Scenes of Jesus's youth based on biblical or apocryphal texts are also missing, except perhaps by stretching the point to include the paintings of Jesus as a child with San José or as part of La Sagrada Familia.

A few paintings of Jesus being baptized by John the Baptist were done, but Christ's ministry and miracles were ignored by the *retablo* painter possibly because it was not traditional to portray them.

The theme of Christ as part of La Trinidad enjoyed moderate popularity. Three identical men are portrayed as the Trinity, distinguishable only by symbols they display on their chests (Nos. 3 and 4). God the Father is in the center with the sun. Christ, his Son, is on his right with the stigmata clearly shown on his hands and feet and a lamb on his breast. The Holy Ghost appears on God's left with his attribute, a dove. A sphere under their feet represents the world and their dominion. These two examples give a nice contrast between a smooth, polished rendition and one that is much more naïve. The use of the red line of God's robe in No. 3 adds charm and excitement to the figure.

During the Middle Ages people wanted to know more about the lives of their heroes, and in response certain legends arose about Christ and his parents, some of which are depicted in this exhibit. The Tree of Jesse is a decorative device illustrating Christ's genealogy, based on Isaiah's prophecy. This prophecy has been condensed in the Hispanicized version and may be better retitled The Tree of David (No. 2). Another is La Mano Poderosa (the Powerful Hand), a representation containing Jesus, Mary, Joseph, and Mary's family (No. 5). Not too common, but seen with some regularity, the theme is a complicated combination of elements of the Eucharistic Man of Sorrows and the "Anna-hand," a cult centering around the supposed mother of Mary that was introduced into Austria in the late seventeenth century.[25] La Sagrada Familia (the Holy Family), another popular *retablo* theme, shows Jesus walking or standing between his parents. In No. 6 the addition of symbols of the Trinity raise this family portrait to a different category, an earthly and heavenly Trinity. The child in this particular piece is shown with symbols of his predetermined destiny, a cross in his left hand and *tres potencias* emanating from his head.

Scenes from the Passion show the flagellation of Christ (No. 7) and Christ after the flagellation (No. 9), both uncommon themes. There does not seem to have been much interest in *láminas* that depict Jesus carrying his cross on the road to Calvary or scenes commonly used for the *viacrucis* (Stations of the Cross) except as devotional figures. In No. 10 it is obvious from the embellishment of the garments and cross, the pearls that bind his hair, and the little cushioned pedestal that holds his hand that these are devotional figures rather than any artist's attempt to depict the event. In No. 15 note also the decorative treatment of the cross. No. 10 is most likely a *paso* figure, usually a life-sized, polychromed figure robed in real garments that is carried on a platform in a procession through the community at certain times of the year, usually during *semana santa,* Holy Week, the seven days before Easter.

La Verónica (The True Image) or El Rostro Divino (The Divine Face) was derived from the Stations of the Cross, a series of fourteenth-century Franciscan devotions (No. 8). Legend tells us that the vernicle, or cloth used by the pious Veronica to wipe Christ's face on his way to Calvary, was miraculously imprinted with his image, a popular subject among *láminas.*

There are possibly hundreds of locally revered images of Christ crucified, but without titles or distinctive attributes, they are impossible to place, such as No. 11. Nos. 12 and 13,

however, are either labeled or have such distinctive characteristics that there can be no confusion as to the name or site of veneration. The Eucharistic Man of Sorrows (No. 14) clearly projects the idea of divine sacrifice. Lambs cluster around the kneeling figure of Jesus, occasionally drinking his blood. The Agnus Dei is in the center of the orb upon which he kneels. The angel holding the chalice with a Host above it is an unusual touch in this piece.

El Niño Perdido (No. 16) and El Niño de Atocha (Nos. 17, 18, and 19) represent devotional figures whose imagery is based upon a small sculpted figure. The first has a limited devotion mostly around Cuencamé, Durango, while the other is one of the most popular figures represented not only in *retablos* but in contemporary religious art. The frames on Nos. 16 and 17 give the viewer an idea of the original appearance of some of the *láminas*. No. 19 is a print that very well could have provided inspiration for No. 18.

Mary

Marian themes outnumber all others. Mary's birth and childhood rarely are represented in *lámina* art except in association with her mother, Ann, who usually is depicted showing her daughter the prophecies concerning the coming savior. Her image also appears in association with Christ but she never is shown alone with Joseph.

La Dolorosa is a fairly common theme. The *retablo* artist often portrayed the sorrowing mother of Christ with a great deal of pathos, and this apppears to have been an extremely desirable depiction of her because so many of them manifest it. Mary appears in dark clothing, veiled, in mourning. She gazes upon the crown of thorns, the nails, and sometimes other symbols of the Passion while a dagger pierces her heart—an allusion to the Seven Sorrows of Mary (Luke 2:35). The artist who painted No. 26 has a little better control of the subject than many, although he or she appears to have gotten caught up in techniques for molding clothing and flesh. The little angel in the corner using his wing to wipe his eye is a nice Victorian touch. Certain figures are so consistent in detail, iconography, and pose that they are immediately identifiable. Foremost among these are N. S., Refugio de Pecadores, N. S. de Guadalupe, La Santísima Madre de la Luz, and N. S. de Pueblito de Querétaro; in approximate order of the percentage of their occurrence in *retablos santos* art (Nos. 22, 23, 24, 25, 29, 28, 31). The variety of Refugios in this exhibit provides a nice representation in drawing skills, with the addition of flowers, angels, stars, and so on, yet the figure remains essentially the same. No. 24 is the closest to the image in the Cathedral of Zacatecas; however, it is far from an exact copy.

N. S. de San Juan de los Lagos is usually flanked by two candles, and her blue robe and flower-covered dress with its ruffled collar are important clues to her identity. In No. 34 she appears in her niche above the tabernacle at the church in San Juan de los Lagos, Jalisco, Mexico, incensed by angels. Two other figures usually identifiable by their clothing are N. S. del Carmen and La Soledad. Although there may be slight differences in the poses, the Virgin of Carmel always holds the Christ child in her left arm and both Virgins are crowned and hold scapulars. The Virgin of Carmel is usually dressed in the brown robes of the Carmelite order and the distinctive coat of arms of the order appears on the scapular or on her dress (No. 33).[26] No. 27 shows Mary in mourning, alone. This figure with the bow at the bottom of her dress

is somewhat unique and probably illustrates a particular statue in some *santuario* (shrines) in Mexico.

N. S. de Rosario can be a little difficult to identify (No. 32), but she always wears a crown and holds in her a right hand a rosary and in her left the baby Jesus. In churches there are popular figures of Mary from whose hands a rosary has been hung, replacing perhaps a scepter or candle. This attribute can become incorporated mistakenly with the piece and then N. S. de Rosario becomes only a generic designation.

N. S. de Cueva Santa, a nineteenth-century import from Spain that appears in only a small number of *láminas,* is distinguishable mostly by the cave in front of which she is placed. A crown usually appears overhead, sometimes suspended by angels. Without the crown or cave, the figure is still recognizable by the bust length and the manner in which her white robe and veil are pulled together. The detail in the clothing is particularly nice here, as are the colored ripples at the bottom of the *lámina* (No. 35).

N. S. de Ocotlán is an extremely unusual figure in tin paintings probably because tin painting was not traditional in Tlaxcala (No. 36). The statue in the Santuario de Ocotlán does not resemble this image in posture or demeanor. The church figure is rigidly upright and clothed in actual garments, while this representation depicts Mary's appearance to Juan Diego in 1541 at the spring of healing waters. The medallions in the upper and lower right represent the state of Tlaxcala and Mexico, respectively. A view resembling the sanctuary is on the other side of the Virgin.

There are a number of *láminas* of Mary that simply show her crowned, cradling the child in her left arm and holding a candle, a scepter, or flowers in her right hand. Titles of these pieces include N. S. de la Candelario, but some are dependent on local usage and have no labels, simply becoming types.

The Archangels

Although there are seven archangels, only two appear with any regularity in Mexican art. No. 1, an entire altarpiece, extremely rare and rich in the number of saints and details, shows all seven. This piece deserves special comment. Just as in the church altarpieces, the figures are stacked on top of each other and balanced on either side: San Joaquin appears opposite Santa Ana, and the devotional figures of Jesus are opposite the medallions representing the founders of religious orders. La Inmaculata, la Trinidad, la Verónica, and el Padre Dios, crowned in a papal tiara holding the dead Christ, occupy the center section, while figures in purgatory are seen at the bottom.

The engraving of the seven archangels (No. 39) is especially significant because seven *láminas* in one collector's possession were done from this one print. One of these, San Gabriel (No. 49), is contained in this exhibition. One can see that the artist copied not only the poses and the clothing with their folds, but the labels, angles, and all. San Miguel and San Rafael (Nos. 65 and 68) have both been reduced to doll-like characters with chubby bodies, bland expressions, and nonheroic stances. The devil in No. 65 does not seem too concerned but has instead a rather puzzled expression, as if he cannot figure out why an archangel is standing on

his back.

The Saints

The remaining figures can be divided into the following subjects: biblical, warriors, members of religious orders and their founders, secular priests, queens, martyrs, spurious saints who were removed from the Catholic calendar, figures representing the parentage of Christ, the Fourteen Holy Helpers, patrons for various professions, and protectors from specific problems. Some fit into more than one category. Individuals from biblical texts are New Testament except in extremely rare instances.

San Acacio, San Bonifacio, and San Expedito (Nos. 40, 45, and 47) are all portrayed as soldiers and all three were martyred. Santiago (the apostle James the Greater) and San Martín are portrayed on horseback and therefore are considered warriors also (Nos. 53 and 64). San Acacio many times has elements at the foot of the cross and in the background that portray him as more modern than Expedito or Bonifacio; in fact these elements may be "Mexicanized." This particular *retablo* shows a most interesting costume—something resembling a colonial gentleman's or official's jacket on the top and bird feathers below (probably an attempt to imitate the segmented protective armor that covers the hips and loins of Roman soldiers, such as San Bonifacio wears).

Members of the religious orders of Friars Minor and Minims (Franciscan), Discalced Carmelite, Augustinian, Benedictine, Mercedarian, Dominican, and Camillians (Ministers of the Sick) are all represented here, as are bishops, doctors, a priest, a deacon, and a vicar general.

San Geronimo (No. 54), who translated the Bible into Latin, and Santa Elena (No. 51), Constantine's mother and the discoverer of the True Cross, were contemporaries (late fourth century). Both figures have distinctive attributes. Santa Elena is identifiable not only by the cross, crown, and nails, but her costume is that of a queen and she usually wears an exotic turban to inform us of her near-Eastern ancestry. Among Jerome's most important attributes are a lion (acquired through a copyist's error), his red robe, and items that define the period he spent as a penitent and hermit in the Syrian desert.

San Francisco de Paola (No. 48) is usually shown with a lamb coming out of a flaming oven; but his habit, white beard, and the word *caridad* surrounded in flames somewhere in the painting clinch the identification. There are a number of *láminas*, however, containing simply a bishop or a Franciscan, whose appellation is uncertain.

Santa Librata (No. 62), Santa Ana (No. 42), San Expedito (No. 47) and possibly San Acacio (No. 40) are examples of the few figures seen in *retablo* art that are the results of pious fiction, more folk tradition than fact. Both Librata and San Acacio are members of the Fourteen Holy Helpers, a group of saints with special intercessory powers.

While most of the figures on *retablos santos* remain on the official Catholic calendar or are listed in *Roman Martyrology,* some of the imagery is never seen in church art. Other images are disappearing through a systematic church policy of focusing on a few significant individuals of general importance. In this manner not only are the images of nineteenth-century popular traditions disappearing, but the little homilies are as well.

While the *retablo santo* ceased being painted around the beginning of this century, the *retablo ex-voto* tradition appears to be as strong as ever. The former could be replaced by mass-produced items, but the latter are strictly individual. An *ex-voto* essentially is the completion of a vow, a gift offered to a religious personage who in turn rewards the seeker with material, physical, or spiritual aid. In an attempt to understand and control their world, human beings through culture and religion have placed all aspects of life—including meteorological phenomena and the elements—under the protection of something greater than themselves, which inevitably has acquired human traits. Humans consider that the gods, saints, spirits, enlightened ones, whatever, take an interest in human endeavor; are pleased with obedience, piety, and loyalty; grant wishes; appreciate gifts; and are not above bribery or, according to many popular accounts, beyond intimidation. There is the implication that if San Antonio, for example, would just help a person find some lost object, she in turn might make public his power. And if that does not work, the saint might surely capitulate if his image is turned to the wall, stood on its head, or placed in a dark chest!

Small objects in the shapes of limbs have been found in Spanish Roman ruins but the tradition is at least as old as the Greek culture and probably predates it. While the custom of appealing to Christian saints was certainly imported to Mexico by the Spanish, there already existed among a number of Indian groups in Mexico the tradition of giving objects in thanksgiving to their deities.

The painted *milagros* truly are an anecdotal art. In most of them a scene appears in which the victim is in the throes of a situation that has no earthly remedy. There usually are three distinct divisions. The center section contains the supplicant and occasionally members of the family either embroiled in the action or kneeling in gratitude for the blessings received. The bottom contains the text, a stately message that carefully describes the date, the incident, the helplessness of the situation, and the nature of the invocation. A section at the top or to the side contains the image or images invoked. They appear just as if they had been painted on a *retablo santo* or as they may have appeared on an altar with no interaction between the donor and themselves. The saints are in their own realm. Whereas the painter of the *retablo santo* must work within strict confines to provide an image as close to popular demand as possible, the *retablo ex-voto* presents opportunities for demonstrating great creativity. Color and drama abound. Women, men, and children are dressed in their best and the sick bed is covered with fringes and swagged drapes. The horizon is often tipped up surrealistically to show the objects in the back to greater advantage, and the characters often are stacked behind each other. Sometimes the victim is shown in different stages—actively involved in the incident, and passively, as supplicant.

Besides testimonies to faith there are other object lessons here. To begin with, here are peeks into people's homes. We may not be seeing their exact bedroom furnishings (which may not have consisted of much more that a *petate* to sleep on and a chest for storing valuables) but a decor that might have been considered more appropriate. The *ex-voto* is an opportunity to have something made to order, and one would want to get his or her money's worth. Chamber pots are frequently shown under the beds, a devotional image might be framed on the walls,

and the ceilings are beamed and tiled floors carefully outlined. Equally important are the clothing styles. No. 74 shows a stylishly dressed gentleman whose trousers are split up the sides with a different material inserted and buttons or silver conchos along that seam. In No. 79 the men's serapes have been pulled over their left shoulders so as to show off the patterns. The one in the center probably came from Saltillo, a city known for its exceptionally fine serape weaving. Some are unintentionally humorous, like No. 80 in which a woman is caught while trying to descend from a moving train, or intentionally, as when a desperate spinster manages finally to get married (No. 81). The covert message of *ex-votos*, even the recent ones, may be the frightening lack of adequate medical attention. People truly had very few options when they became ill; indeed, it was a miracle that some recovered at all.

The Artists

Who were the artists and what do we know about them? Except for very rare cases, the *retablos* were never signed and the *milagros* only occasionally (mostly beginning in the mid-twentieth century). Why the overwhelming anonymity? From the care lavished upon some of the *retablos,* we know that considerable time was spent. Didn't the artist wish to claim them? Could piety and the inappropriateness of a signature be a possible explanation? Perhaps *retablos* were not perceived in the same way that artists and craftspeople in this century perceive their works— not as works of art, in other words, but as products. The creators of the *retablos* were simply performing a job. Their egos probably were not involved, as it did not seem to have figured in the identification of their oeuvre. Perhaps the *retablos* were even painted in a production line, with groups of individuals doing specific parts of the painting. There remain thousands of square yards of anonymous religious paintings on canvas in Mexico today, an accumulation of over four hundred years in support of the theory of a workshop/craftsperson mentality. The word *commodity* is a bit cold to describe the artist's function, but the creation of these necessary domestic articles in quantity and inexpensively might have been perceived as such. If the *retablo santo* had persisted into the twentieth century the growing awareness of the artist's individuality probably would have led to signatures on the little paintings. The *retablos ex-votos* are more frequently signed now, in the latter part of the twentieth century. The artist is beginning to realize that he has an opportunity to advertise his abilities and attract future clients, and sometimes even an address is included.

Did the artists create objects other than *retablos?* Most likely many painted the *ex-votos* too. (So far there is little evidence to prove they carved and painted *santos bultos,* the three-dimensional pieces, but this is a distinct possibility.) And although more research needs to be done in matching the techniques and styles of *ex-voto* painting with *retablos,* matches can be found. In this manner a definite grid of working dates for some artists and possibly their areas of production could be established. I also have been able to determine that some of the more competent artists such as the Bee-Stung Lip Painter and the San Luis Potosí Painter were active in the 1890s. In the case of the latter I have also established a tentative location for his opera-

tion within the city, the capitol of a state by the same name.

There are always exceptions, of course, and one rare one is the D. A. Painter. Not only have his name and his active dates been discovered, but perhaps where he lived. Nancy Hamilton of El Paso, Texas has been intrigued for years with the initials *D. A.* that appear on the face of his paintings. From the many she has studied she concluded that his years of production were from 1861 to 1877, representing twenty different subjects. He usually drew only his initials and dated his pieces, but in 1870 he wrote his full name, Donaciano Aguilar, on the reverse of one. What is more exciting is that this work was collected in the Juchipila Valley in the state of Jalisco where others by the same hand have been found. Among his signed pieces there is an inconsistency of quality—some were done with more care than others—suggesting a workshop production, with Maestro Aguilar placing his initials on the paintings before they left the studio.[27]

Even unsigned as No. 25 is, the D. A. Painter can be picked out. He has a characteristic way of outlining his figures and creating lines by placing contrasting colors and hues next to each other. The proportions from the chin to the mouth, nose, brow, and so on as shown here are typical. He was fairly literate, as demonstrated by his inscription, "se comenzo el Dia [*sic*] 4 de Agosto de 1869 ha debocion de Josefita Sanchez," and the way he makes capital *D's* are distinctively his.

I have assigned working titles to certain individuals or groups, based mostly on diagnostic characteristics of most of their work. Artists probably did not travel too far from their home bases even to take their *retablos* to the fairs. It is logical to presume that many *ex-votos* were also produced locally with individuals seeking out an artist in the town where a saint was said to have performed a miracle. If a *retablo santo* was done by a certain artist of a regionally important figure, and *retablo ex-votos* by the same artist exist in surrounding churches, there is a good likelihood that the artist is from the region.

In a number of collections we find a very particular image of a crucified Christ. Besides the velvet fringed loincloth with symbols of the Passion, he has a crown of thorns that incorporates the *tres potencias* and a large gold halo that might almost be considered a mandorla. Most distinctive, though, is the series of little angels holding additional symbols of the Passion in their own mandorlas that appear to be floating in a vine of white flowers. The sun and moon are at the top and statue figures of the Mater Dolorosa and San Juan Evangelista flank the central figure. This is El Cristo de Saucito, an important pilgrimage figure at a site just outside San Luis Potosí. The artist who produced hundreds of this particular image also produced *ex-votos* thanking San José in the neighboring church of San Francisco in the city of San Luis Potosí, hence his name, the San Luis Potosí Painter. The dates on the *ex-votos* range from 1884 to the 1890s. No. 12 is by this artist. Other *retablos santos*, particularly those of San José, N. S., Refugio de Pecadores, and El Niño de Atocha are strongly reminiscent of this person's color scheme, which runs toward soft blues and beiges. Most definitive though are the outlines, which are done with a very fine brush in a sepia-toned color. Eyes become a formula of three arcs, two raised and one lowered, with the eyeball between the bottom two.

N. S. del Rosario de Talpa (No. 32), San Antonio de Padua (No. 43), San Benito de Pa-

lermo (No. 44) and San José (No. 60) are all by the same individual. Prior to gathering this exhibition I had noticed one or two of these particularly bold, straightforward representations but dismissed them as aberrant examples. Now, after seeing about twenty-five of them in various collections, a definite consistency appears. Although there are differences in proportion, perspective, and anatomical features, the figures all have an appealing vigor. There is a stout, blunted quality not only in the images, garments, and decorations but in the brushstrokes as well. *Chunky* seemed an appropriate description, hence the name the Chunky Painter. No *ex-voto* has been linked to this artist, but the color tones suggest the end of the nineteenth to the early twentieth century.

One of the most interesting groups of artists has been given the title the Bulbous-Headed Family. A number of common characteristics among these painters lead me to believe there was close contact among them (Nos. 18, 22, 23, 52, 58). To begin with, in most cases the head—especially the forehead—is very large and round. San Isidro, El Niño de Atocha and N. S., Refugio de Pecadores have identical features. They also share a rather exuberant foliage and the manner in which the finger- and toenails are painted. The Refugio in No. 22 and San José have the same eyes, lips, and noses, while the two representations of the Christ Child have similar noses, chins, eyes, and lips. Their nails match the other three and the child accompanying San José has the same peculiarly tied belt. The two children held by the Refugios wear almost identical gowns. This group can be expanded to include a number of other pieces that vary slightly but share identical crowns, halos, vegetation, belt, *huaraches,* and facial features. Not all of them contain all elements, however, and I wonder whether the works are the result of a workshop where everyone borrows everyone else's ideas or where certain artists are responsible for particular details. No *ex-votos* have been found by these artists but some of these were collected in southern Durango.

Beyond analyzing certain features, as a group the pieces are extremely appealing in their exciting use of colors and forms. Some pieces, though, have a rather threatening quality. The flowers surrounding the Refugio (No. 23) look as if they could eat someone if they got close enough, and El Niño's handful of wheat stalks have been developed into something resembling an exploding rocket. All these figures demonstrate great imagination and ingenuity in the arrangement of their elements. San Isidro's gourd water bottle, for example, seems to be tacked to the edge of the tin's margin. The lines where the colors and the patterns of the garments come together are animated, El Niño's chair back appears to be made from a *petate,* and Mary and her baby share the space with a crucifix. From the mouth of this crucifix comes an inscription that is readable only by placing it next to a mirror. This peculiarity has suggested the title the Dyslexic Group; the letters aren't reversed, however, instead they are mirror images. The artist either was illiterate and in the copying could not tell whether the letters were correct, or, even better, the inscription is written for the Refugio's benefit. Within this group of painters there are samples of other labeling, such as saint's names at the bottom of the tin, but they are always in cursive script and are not reversed.

As mentioned previously, Nos. 15 and 10 are by the same hand and have a distinctive Byzantine nature, earning their artist the title the Iconic Painter. These depict locally impor-

tant figures in the states of Puebla and Tlaxcala, but we have not seen enough samples yet to amend the title to perhaps the Pueblan or Tlaxcalan Iconic painter. Puzzling is the fact that Nos. 10 and 36 have a definite South American colonial flavor, with elements such as strands of pearls in the hair, floral decoration, and the use of gold paint. If it were not for the fact that the paintings of N. S. de Ocotlán and N. S. de los Trabajos de Puebla are definitely Mexican subjects and N. S. de los Peñas is by the same hand as N. S. de los Trabajos, a case might be made for a Cuzco or Alto Plano school of paintings on tin.

The Red-Bole Group was one of the most prolific and contains perhaps the largest number of artists. I named this group in my book, *Mexican Folk Retablos,* because of their technique of applying a reddish-brown primer to the tin surface prior to painting. As the surface paint becomes more transparent with age, the priming becomes visible, sometimes so much so that the contrast between light and dark on the flesh sections becomes dramatic. Bole is a smooth red clay originally used on wooden surfaces as a preliminary step to gold leafing that deepens the gold color and assists in the burnishing. This red surface preparation continued among certain schools of painting in Europe and the New World in the sixteenth, seventeenth, and eighteenth centuries. Other features such as fleshy eyelids and pouting lips might link many of these painters to the Italo-Byzantine influence. There is also a loose, masterful way in which the brush applies paint to highlights and a general high quality in the design, drawing, and modeling. No. 2 belongs in this category. There are also *ex-votos* done by the Red-Bole Group with the typical burnt-red color glowing through a transparent overpaint. Although the dates were taken mostly from *ex-votos* done by one individual, they were in the early 1880s through the mid-1890s.

The Ball-Beard Painter was given this name because of the odd manner in which beards are depicted on male figures. The cheeks are shaded, giving a five-o'clock-shadow effect. On the chin the beard is neatly divided in the center with both sections terminating in what appear to be little furry balls. So many of these *retablos* are alike that either a very prolific artist, a workshop, or imitators are responsible. *Ex-votos* in this style are dated in the 1890s. This artist delighted in smooth surfaces and flowing lines and one senses that he or she was striving very hard to emulate the chromolithographs. The eyes tend to be bulging and the shading of the hands and feet give them a swollen appearance. Nos. 4 and 57 are by this artist or workshop.

One individual most influenced by the Italo-Byzantine imports was one whom I named the Bee-Stung Lip Painter, whose style No. 21 graphically demonstrates. In addition to bulging, darkened eyelids, the noses are long and narrow and end right above the mouth, which is comprised of a darkened line with highlighted pink areas in the center of the upper and lower lips. Shading around this area helps reinforce a pursed, pouting appearance. Chins and nostrils are outlined and highlighted in a manner strongly reminiscent of fourteenth- and fifteenth-century Florentine and Sienese masters. Vegetative motifs and details on garments and furnishings are adroitly handled and decorative. Fairly prolific, this artist produced *ex-votos* from 1882 to the late 1890s. No. 67 is another example from that hand.

The Calligraphic-Line Painter (Nos. 33, 46, 68, and 71) could have studied with this individual, or at least he was strongly influenced by the same Byzantine material. Everything here,

though, is frugally condensed into a series of lines. The farthest eyebrow and nose are one line. The lips are another line, appearing almost to be buttoned shut with two tiny red dots. The garments are almost devoid of shading and instead employ lines to divide sections, cuffs, or edges. Eyes, ears, and tendrils of hair are still more lines. I have not seen *ex-votos* by this individual but based on the high colors suppose they were produced toward the end of the 1800s.

The Skimpy Painter is so named because of the extremely thin manner in which the paint is applied in most examples (No. 72). Hands are little pads of light color with fingers and thumbs drawn in with brown paint, and faces have a minimum of shading under the jaw and brows. The eyes, nose, and mouth are created with stiff lines. Profiles have heavier lines blunting details. Clothing lacks molded detail and depends upon lines to provide definition. If there are buildings or other objects, the color is simply laid on and a shape drawn around it. The background colors are light blues and greens with paints barely washed over the tin. Particularly characteristic are the halos on some figures: an incomplete oval is drawn and then two or three ditto marks placed in about the center. The eyes and mouth have a rather harsh appearance possibly because of the lack of shading or the difficulty in painting a three-quarter view. Images of N. S. de Lourdes, San José, and El Niño de Atocha appear to be favorites with this artist, although he or she had a fairly wide range of other subjects. The light colors indicate the end or turn of the century. I am not aware of any *ex-votos* done by this artist. There appear to be more than one individual working in this style, and initials, not always the same, are occasionally found on the reverse.

This grouping process is by no means complete and is just in its beginning stages. There are hundreds of artists and many more matches to be made, and the key appears to be the *ex-voto*. There are many artists sharing a number of features such as bulging eyes, long noses, and swollen extremities. How much is exchanged or copied, how much can be ascribed to general ineptness or is the result of copying certain imported prints we may never know. Unfortunately the almost ephemeral quality of inexpensive paper prints has eliminated a great deal of comparative material and we do not have the artists to ask.

Were all the *retablo* painters men? I doubt it. Although we know women were restricted from association in most guilds, *retablo* painters came after the guilds were officially disbanded.[29] (So many artists scattered over such a large, mostly rural area would have been impossible to regulate anyway.) Again, making assumptions based on modern behavior among craftspeople, usually the entire family is involved and it seems likely the pieces were produced in small family workshops. Considering the involvement of women today in family industries and the tradition of women craftspeople, it is more than probable some of the artists were women. Anonymity hides not only the name, but the gender as well.

Frames

A good percentage of *retablos santos* were framed, perhaps in the same shop that created them. Here again, we are hampered from drawing too many conclusions because of incomplete sam-

ples. Many *retablos* have been removed from their original frames. Coulter and Dixon recently published research on New Mexican frames that provides a great deal of needed information on materials and techniques as well as certain workshops and groups. No such research has been done on Mexican samples, but based on the similarities in technique and general appearance and geographical proximity, it would not be risky to draw a few parallels.

Tin frames for *láminas* were created as *nichos,* with the painting set back from the glass, or the painting was designed to be placed almost flush to the frame. The tin pieces were cut and shaped and designs and patterns scored, crimped, pounced, and punched into the material. Sometimes they were joined at the corners and all the parts were soldered together. Glass was used as a protection over the painting (sometimes set in a hinged door in the *nicho* variety) as well as a decoration. The undersides of a glass surface were painted, and painted strips of glass frequently were placed over colored paper or foil, creating an even livelier effect.

Many pieces were strongly influenced by late eighteenth-century Federal-style frames. This style is characterized by bosses in the corners (in the shape of a rosette or a square) and the use of half-rounded column moldings that frame the pieces and pediments, and pendant and swag motifs on the sides. The pediments take forms ranging from simple lunettes to features having a life of their own. No. 19 is such an example, with its pediment in the form of a spiky sunburst overwhelming the little print and rosettes on the sides competing for attention with the bosses in the corner. No. 16 has a similar form that is combined interestingly with the side's pendants. No. 38 was obviously created by the same individual. Another interesting combination can be seen in the pediment in No. 17 where scallops have been enlarged into a radiant sunburst. These side pieces range from hanging drapes or foliage designs to shapes resembling misshapen ears or atrophied wings. Part of the charm of San Raphael's frame (No. 68) is that these pieces appear almost to be an afterthought or an attempt to undo some of the impact of the bosses, which overwhelm the pediment and gobble up the frame.

The frame for San Benito (No. 44) reduces the small *retablo* to secondary importance. This delightful example of tinsmithing acquires a life of its own, instead of merely framing the piece and giving it honor.

San Jeronimo's frame (No. 54) has a distinctive patriotic flair with the tri-colors, and either age or intention has created some very pleasant, muted, and subtle color and surface combinations.

To expedite their packaging and transport, many times the frames were removed from the *retablos* many times. Spots of solder on the reverse of the *retablo* are a good indicator that a frame was once attached. Other *retablos* without the solder that also lack holes for hanging and that do not have the typical crinkled corners from having fallen on the edges were probably framed, too. These could have been slipped behind a frame into a soldered channel. Examples in perfect, unmarked condition were likely kept under glass. It is unfortunate that so many *retablos* are missing their frames. They are usually fine examples of tinsmithing and besides protecting the piece, present it in its original setting.

Collectors and their Criteria

In Mexico a few small collections of *retablos ex-votos* existed prior to the 1940s (there were those of Kahlo and Fernandez Ledesma and references to others in the writings of Montenegro, Fernandez Ledesma, and Brenner), but large collections of *retablos santos* are limited in number. By and large, what would appear to be a logical and significant area for collection and research by Mexicans has not been developed. A number of explanations are possible.

Dating from the nineteenth century in Mexico there seems to have been a scorn of anything Spanish, and after the revolution of 1920 a movement to establish a national identity through the Indian cultures, particularly pre-Columbian, gained popularity. The movement was fueled by the so-called "black legend" of Spaniards as devils, responsible for all the country's social and political woes. This legend unfortunately affected twentieth-century appreciation of the previous four hundred years of art and architecture.

In the 1950s American collectors began to appreciate Spanish colonial paintings and sculpture. These buyers also discovered folk art and crafts, and dealers, responding to the heightened awareness and higher prices of North American folk art and the interest in all things Mexican, began actively pursuing those markets. The paintings on tin already had been swept up by the *buscadores* and were of immediate appeal. Among the Mexican bourgeoisie the tin paintings were considered *arte popular,* crude and ordinary. While Mexicans may have admired pre-Columbian art, they seemed to look to European standards of beauty in paintings, porcelain, and furniture. Their appreciation even of Spanish colonial art comes later, partially through the pioneering research and writings of giants like Francisco de la Maza, Manuel Toussaint, and Abelardo Carrillo y Gariel. It is interesting to note significant pieces and entire collections accumulated by non-native Mexicans in this century, the Mayer and Behren collections being among the most extensive.

Twelve important dealers in Mexico City, Guadalajara, and Puebla were surveyed during the winter of 1989–90 and asked the question, "Who collects *retablos?*" Their clients were largely North Americans, and I discovered that their countrymen did not collect them because of lack of appreciation or because they felt most Mexicans now were priced out of the market.

Can generalities be made about the Mexican and North American collecting mentalities and sense of connoisseurship? Most certainly, and there are some significant similarities and differences. In examining over ten thousand *retablos* in the past three years, 2.5 percent of which were *ex-votos,* I asked a series of questions designed to elicit this information.

In Mexico, if acquired by purchase, a *retablo santo* probably was owned by an educated person with an understanding of Mexican art and culture. The *retablos* were not used as devotional objects per se. If a *retablo* was a family keepsake, it may or may not have been included in a family altar. In the United States no *retablos* were used as religious objects even though a couple of the collectors were devoutly Catholic.

Mexican and North American collections are based on some of the same criteria: the condition and quality of the painting and the subject matter. Among North Americans with larger incomes buying for investment purposes, however, there is an inclination to seek quantity as

well. Many times they are motivated by a desire to have one of each subject or type. Many North American collectors are not Catholic, but Mexican collectors, most likely Catholics, will speak of the *retablos* in association with their lives and culture. Many times the pieces are appreciated because of similarities or dissimilarities to the religious art in museums and churches, and not merely for their condition or type. A *retablo* of N. S. de la Luz may have been acquired because a member of the family had that name, or La Sagrada Familia was kept as a symbol for the family, or perhaps a nineteenth-century image of Mexico's patron saint, La Guadalupana, was preferred to a colored print. Having just a few, a Mexican collector tends to dwell upon artistic details, such as a tender expression on the face of the Virgin. If the figure had been yellowed from varnish, smoked by candles, or faded from touching, it was not necessarily a deterrent to purchasing a piece. Many times these owners have a deep understanding of where these objects fit into Mexico's artistic milieu.

Some collectors specialize in El Niño de Atocha figures, for example, or warrior saints. Others look for unusual imagery or pieces with titles or dates. One doctor collects only *ex-votos* depicting diseases, while another individual favors accidents. Taste also plays a part. Some individuals turn down a crudely drawn figure in favor of one that is more polished, while another would scoop it up for the spirit it represents to him or her. Nelson Rockefeller had excellent examples of *ex-votos* and *láminas* but regarded them as only part of his large collection of Mexican folk art.[30] Folk art specialists in Mexico, Dr. Ruth Lechuga and Sra. Teresa de Pomar, have similarly diverse collections. Several large collections were amassed in or near El Paso, one of the most important distribution points from the mid-1940s because of its proximity to Juárez, Chihuahua. These collections were later given to museums, notably the El Paso Museum of Art and the museum at New Mexico State University at Las Cruces. Collectors and collections originally were located in states with a Hispanic tradition, notably New Mexico (and in particular Santa Fe), Arizona, Texas, and California, but this is no longer true. The interest in the subject has expanded to include collectors and dealers in New York City, Washington, D.C., Philadelphia, Chicago, and other urban centers.

In considering an object out of context it is sometimes difficult to establish a rapport. I have visited Mexican homes on many occasions to examine the ubiquitous altars, and I have also visited many pilgrimage sites and *santuarios* throughout Mexico. The atmosphere surrounding the objects is completely unlike that of a sterile museum exhibit or a collector's home. In their original settings the devotional pieces—*láminas*, engravings, or statues—perform the function of focussing one's faith. The images of Mary, Christ, or the saints may be draped with a rosary, with additional religious mementos sharing its frame or space. A candle nearby may be kept lit, and flowers may adorn the piece on special occasions. Family photos, tokens from stays in hospitals, and significant letters may be clustered around it, adding power to the space.

Ex-votos are crammed by the hundreds onto the walls of the chapels at important pilgrimage sites, and one or two can be found propped against the base of a statue in indistinguishable village churches. All poignantly speak of a faith shared by individuals testifying to the efficacy of the devotional figure. The miracles are there for all to acknowledge.

The process of color lithography probably caused the demise of the painted *retablo*, al-

though there was a time at the end of the nineteenth century when it, too, was used for copying by the *retablo* artist. Apparently there was no particular consumer loyalty to the handcrafted product or to the artists. The very human desire for something novel, modern, colorful, and, most certainly, less expensive led to a preference for products of advanced technology.

The prognosis for the tradition of painted *ex-votos* is guarded. As the devotions to minor figures in obscure villages become less important, the *ex-voto* is becoming no more than a curious token. When pieces are removed from the walls of churches for housekeeping they often are sold to the *buscador*. The ease of obtaining a molded *milagro* compared with the effort to have one painted, and the perception of the painted variety as old-fashioned all have contributed to their gradual disappearance. Similarly, other objects like crutches, x-ray plates, and photographs are now considered desirable. The attitude of the clergy is also important. A number of priests have informed me that they regard the *retablo ex-voto* as clutter, and that they prefer the small, silvered *ex-voto* because they are easier to display and can later be taken down and resold! Others have said they felt the *ex-votos* were genuine expressions of the Mexican spirit and that they encouraged them. Two sanctuaries in particular—at Plateros and at the Basilica of Guadalupe, Mexico City—have displayed their *ex-votos*. Another site at San Juan de los Lagos solved their storage and display problem by disposing of the excess, selling them to Mexican antiquarian dealers. Whether or not pilgrims and recipients of miracles will continue the tradition of the personalized *ex-voto* is open to speculation. The pressures of modernization, diminishing interest in certain traditions, and a lessening of the church's role as a community focus, while certainly not endemic to Mexico, all will play important roles.

NOTES

1. *Santo,* meaning *holy* or *saint,* is used as a prefix to an individual's name to indicate the honor given him or her by the Catholic Church. The term is also used with a local cult or applied in a broader sense to religious images, most frequently three-dimensional figures, or *bultos.*

2. and 3. I am surprised by the absence of references to the paintings of saints on tin in sources by writers who prided themselves on their appreciation of popular folk art. Although Dr. Atl, Anita Brenner, Gabriel Fernandez Ledesma, Roberto Montenegro, Frida Kahlo, and Diego Rivera have praised or collected the *retablo ex-voto* and perhaps even found inspiration in the form, the *retablo santo* is virtually ignored in their writings. The lack of appreciation may stem from the fact that Mexican art historians looked to Europe for their artistic criteria, even while condemning European influences for contaminating Mexican art.

4. Montenegro includes several eighteenth-century examples, beginning in 1743, which appear to be canvas.

5. See works by Sobré and Buendía.

6. See Vargas Lugo.

7. Toussaint, *Colonial Art in Mexico,* 20 and 38, and *Pintura colonial en México,* 20–22.

8. MacLochlon and Rodriquez.

9. Parallels between Christian legends and native beliefs were encouraged by the early clerics. The foremost example might be the Virgin of Guadalupe, who was said to have appeared auspiciously in December 1531 on the hill of Tepeyac and express a wish to have a church built there. Her appearance neatly replaced the Aztec goddess Tonantzín by retaining traditional worship at that site. Although it was not supported in the beginning by either Dominicans, Franciscans, or the Augustinians but by the episcopate, the cult flourished. Ricard also mentions that the only actual substitution of a native shrine is Chalma, southwest of Toluca in the state of Mexico, a grotto where around 1540 the Augustinians removed an idol and replaced it with a crucifix. The shrine rivals Guadalupe in popularity.

10. Brenner, 127–156 and Ricard, 30–37.

11. Toussaint, *Colonial Art in Mexico,* 132–235. Guild ordinances for artists forbade admission to the ranks of *maestro* to blacks, mulattos, or anyone of "*color quebrado.*" See also Santiago Cruz, 19. As late as 1753 the issue of non-Spaniards entering the upper levels of art was obviously still alive. Statutes drafted by Miguel Cabrera for his academy stated that no member could accept mixed blood students and required written documentation for admission (Charlot, 53).

12. The Office of the Inquisition had an undeniable influence on the thematic content of the arts of Mexico, especially during the sixteenth century. Not only were incoming cargos inspected for religious imagery that might be considered dangerously indecent but painted and sculpted works were under constant scrutiny for heretical or pernicious intent. The incident of the Flemish painter Simon Pereyns with the Inquisition in 1568 is perhaps the best known. See Carrillo y Gariel, *Technica de la pintura de Nueva España,* 115–131.

13. Anderson's research to determine figural arrangements in sixteenth- and seventeenth-century altarpieces shows how skimpy record-keeping of the time was. With such a lack of documentation for the large, important structures, the paucity of information on artwork in the home or in private chapels comes as no surprise.

14. I have seen a few paintings of saints on tin in Guatemala but their origin was not definitely known. The differences in style, however, could indicate that they were painted locally and not imported from Mexico. There were equivalent paintings done in Bolivia, an area with abundant tin deposits. Some of these paintings are easily identifiable from the thinness of the metal stock—so thin in fact that if they are held by a corner they have a tendency to bend. The use of floral patterns over garments and generous applications of gold paint on clothing edges, halos, and jewelry also make them distinctive.

15. Coulter and Dixon, 155–62.

16. Bargalló, 295–96 and 350. He also lists the intendancies of Guanajuato (San Felipe), Zacatecas (Villa Nueva and Jerez) and Durango (Coneto), the most important producer. Aguascalientes was the fourth most important state of production, but Teocaltiche in the northeast corner of the present state of Jalisco was also important.
 There are nineteen states in Mexico where tin is found today, but the mineral is still gathered by placer mining. Not until the middle of this century did advancement in founding techniques make the product competitive.

17. See Barrett, 11 and 91–101, and Adams and Chavez, references throughout.

18. The availability of tin was also an important factor in certain areas of Mexico for the production of maiolica (a tin-glazed pottery technique imported from Spain but having Moorish antecedents).

19. I am presently conducting research on the reasons for the destruction of paintings on tin and their preservation, and the effects of tin disease. Although it is too soon to make too many conclusions, I have made some important observations. Besides the abrasion caused by the simple removal of paint from the tinned surface, there are other causes of damage. Votive candles placed too closely not only blister the paint off the surface but can cause permanent darkening. Deposits by insects can effectively remove paint, and other accretions can blanch or stain the paint. Oxidation of the iron, or rust, can cause surrounding tin and paint to be pushed up and away. There is also an ionic reaction at the point where tin and iron meet, which may be detected by a gray, powdery effect, especially on the reverse side of some *retablos.* This can be exacerbated by extremely low temperatures, for example. Analyzing the cause of the problems has to occur before prevention and conservation, consolidation and restoration of the artworks can be accomplished.

20. One collection contained a painting of San Benito de Palermo on a piece of tin that was only a little larger than the size of a dime. The collector told me this saint was understood to be the patron saint of prostitutes and, indeed, the piece seems to have been designed for carrying on one's person. The piece appeared to be fairly recent. Another collector had the largest *retablo* ever seen, a piece measuring 32″ × 27″ and having a number of characteristics frequently used by the D. A. Painter. The painted surface is possibly zinc; and although not common, there were *retablos* painted on this metal.

21. Devoe, 37–40.

22. Giffords, 34–42.

23. See Lange's articles on the subject.

24. Some favorite saints such as San Cristóbal have been dropped. Images of Santa Lucía and Santa Bárbara are becoming rarer and San Blas and San Acacio, two popular members of the Fourteen Holy Helpers, are barely recognizable in Mexico today, even by the clergy.

25. Lange, *Household Saints of Puerto Rico*, 186–87.

26. See also Giffords, 55–57. Relying on informants rather than iconographical analysis N. S. San Juan de los Lagos was mislabelled N. S. de Patzcuaro. Also, the fact that the Carmelite coat of arms appears on the garments of the Virgin of Carmel was omitted inadvertently from the book's final draft.

27. Personal communication, Francis Tolland, July 1988 and January 1990.

28. Personal communication with Nancy Hamilton, July 1988, and Francis Tolland, July 1988 and January 1990.

29. The guild system was effectively abolished in 1814 by the Cortes de Cádiz. See Castro Gutiérrez, 130–36.

30. This collection is now shared between the Mexican Museum in San Francisco and the San Antonio Museum of Art.

SELECTED BIBLIOGRAPHY

Adams, Eleanor B., and Chavez, Fray Angelico. *The Missions of New Mexico, 1776: A description by Fray Francisco Atanasio Dominquez*. Albuquerque: University of New Mexico Press, 1956.

Anderson, Barbara Christine. *The Figural Arrangements of Eighteenth-Century Churches in Mexico*. Ph.D. diss., Yale University, 1979.

Atl, Dr. (Geraldo Murillo, pseud.). *Las artes populares en México*. Librería Cultura, 1921.

Bargalló, Modesto. *La minería y la metalurgía en la America española durante la época colonial*. México and Buenos Aires, 1955.

Barrett, Elinore M. *The Mexican Colonial Copper Industry*. Albuquerque: University of New Mexico Press, 1987.

Barrio Lorenzot, Francisco del. *Ordenanzas de gremios de la Nueva España*. Mexico: Genaro Estrada, ed., 1920.

Bloom, Lansing B. "The Chihuahuan Highway." *The New Mexico Historical Review* II, no. 3 (July 1937): 208–16.

Boyd, E. *Saints and Saint Makers of New Mexico*. Santa Fe: Laboratory of Anthropology, 1946.

Brenner, Anita. *Idols Behind Altars*. New York: Payson & Clarke Ltd, 1929.

Buendía, Rogelio. *Obre los origines estructurales del retablos*. Revista de la Universidad Complutense de Madrid: 20:87 (July-September 1973): 17–40.

Butler, Alban. *The Lives of the Saints*. Edited, revised, and supplemented by Herbert Thurston, S.J. 12 vols. London: Burns, Oates and Washbourne, 1926–38.

Cahier, P. Ch. *Caractéristiques des saints dans l'art populaire*. 2 vols. Paris: Librairie Poussielgue Frères: 1867.

Carrera Stampa, Manuel. *Los gremios méxicanos*. México, 1950.

Carrillo y Gariel, Abelardo. *Datos sobre la Academia de San Carlos de Nueva Espāna: El arte en México de 1781 a 1863*. Mexico: 1939.

——— *El Pintor Miguel Cabrera*. México: Instituto Nacional de Antropología e Historia, 1966.

——— *Technica de la pintura de Nueva España*. México: Imprenta Universitaria, 1946.

Castro Gutiérrez, Felipe. *La extincion de la artesania gremial*. México: Universidad Nacional Autónoma de México, 1986.

Charlot, Jean. *The Academy of San Carlos, 1785–1915*. Austin: University of Texas Press, 1962.

Coulter, Lane and Dixon, Maurice. *New Mexican Tinwork, 1840–1940*. Albuquerque: University of New Mexico Press, 1990.

Croisset, P. Juan, S.J. *Año christiano*. 2nd ed. 4 vols. Madrid: Establecimiento tipográfico de Manuel Rodríguez, 1878–85.

Devoe, Shirley Spaulding. *The Tinsmiths of Connecticut*. Middletown, Connecticut: Wesleyan University Press for the Connecticut Historical Society, 1968.

Ebblewhite, E. A. *A Chronological History of the Worshipful Company of Tinplate Workers*. London: The British Museum, 1896.

"Estaño." *Enciclopedia de México*. 3:623, 1977.

Fernandez Ledesma, Gabriel. "The Meaning of popular 'Retablos.'" *Mexican Art & Life* 6. Mexico City: D.A.P.P., April 1939.

Flower, Phillip W. *A History of the Trade in Tin*. London: George Bell & Sons, 1888.

Giffords, Gloria Kay. *Mexican Folk Retablos, Masterpieces on Tin*. Tucson: University of Arizona Press, 1974.

Herrera Canales, Inés. *Estadistica del comerico exterior de México (1821–1875)*. Coleccion Cinetifica Fuentes, 87. México: Instituto Nacional de Antropología e Historia, 1980.

Hoare, W. E., Hedges, E. S., and Barry, B. T. K. *The Technology of Tinplate*. New York: St. Martin's Press, 1965.

The Holy Bible. Douay Edition. New York: P. J. Kenedy and Sons, 1965.

Jones, W. H. *The Story of Japan and Tinplate Working*. London: Alexander and Shepheards, 1900.

Keleman, Pál. *Baroque and Rococo in Latin America*. New York: Macmillan, 1951.

Lange, Yvonne. *Santos: The Household Wooden Saints of Puerto Rico*. Ph.D. diss., University of Pennsylvania, 1975.

———— "In search of San Acacio: The Impact of Industrialization on Santos Worldwide." *El Palacio* 94, no. 1 (summer/fall 1988): 18–24.

———— "Lithography, an Agent of Technological Change in Religious Folk Art: A Thesis." *Western Folklore* 33, no. 1 (January 1974): 51–64.

MacLochlon, Colin M., and Rodriquez, Jaime E. O. *The Forging of the Cosmic Race.* Berkeley: University of California Press, 1980.

Maza, Ana María Roteta de la. *La ilustración del libro en la España de la conterareforma, grabados de Pedro Angel y Diego de Astor, 1588–1637.* Toledo: Instituto Provincial de Investigaciones y Estudios Toledanos, 1985.

Maza, Francisco de la. *El pintor Cristobal de Villalpando.* México: Instituto Nacional de Antropología e Historia, 1964.

Montenegro, Roberto. *Retablos de Mexico.* México: Ediciones Mexicanas, S. A., 1950.

Moorhead, Max L. *New Mexico's Royal Road, Trade and Travel on the Santa Fe Trail.* Norman: University of Oklahoma Press, 1954.

North, Frederick J. *Tin through the Ages in Arts, Crafts and Industry.* Cardiff: The National Museum of Wales, 1941.

Pletcher, David M. *Rails, Mines, and Progress: Seven American Promoters in Mexico, 1867–1911.* Ithaca: American Historical Association and Cornell University Press, 1958.

Réau, Louis. *Iconographie de l'art chrétien.* Paris: Presses Universitaires de France, 1955.

Ricard, Robert. *The Spiritual Conquest of Mexico.* Berkeley and Los Angeles: University of California Press, 1966.

Roig, Juan Ferrando. *Iconografía de los santos.* Barcelona: Ediciones Omega, 1950.

Romero de Terreros, Manuel. *Grabados y grabadores en la Nueva España.* México: Ediciones Arte Mexicano, 1948.

Santiago Cruz, Francisco. *Las Artes y los Gremios en la Nueva España.* México: Editorial Jus, S.A., 1960.

Singer, Charles, Holmyard, E. J., Hall, A. R., and Williams, Trevor I., eds. *A History of Technology.* New York and London: Oxford University Press, 1957.

Sobré, Judith Berg. *Behind the Altar Table: The Development of the Painted Retable in Spain, 1350–1500.* Columbia, Missouri: University of Missouri Press, 1989.

Starr, Frederick. *Catalogue of a Collection of Objects Illustrating the Folklore of Mexico.* Folklore Society, 1898. Nendeln/Liechtenstein: Kraus Reprint Limited, 1967.

Theophilus. *On Divers Arts.* Translation, introduction, and notes by John G. Hawthorne and Cyril Stanley Smith. New York: Dover Publications, Inc., 1979.

Toussaint, Manuel. *Colonial Art of Mexico.* Translated by Elizabeth W. Weismann. Austin and London: University of Texas Press, 1967.

———— *Pintura colonial en México.* México: Instituto Nacional de Antropología e Historia, 1965.

Trens, Manuel. *María, iconografia de la Virgen en el arte español.* Madrid: Editorial Plus Ultra, 1946.

Sill, Gertrude Grace. *A Handbook of Symbols in Christian Art.* New York: Collier Books, 1975.

Vargas Lugo, Elisa. *Las portadas religiosas de México.* México: Universidad Nacional Autónoma de México, 1969.

Vega González, Jesusa. *La imprenta en Toledo, estampas del Renacimiento.* Toledo: Instituto Provincial de Investigaciones y Estudios Toledanos, 1983.

Wolf, Eric. *Sons of the Shaking Earth.* Chicago: University of Chicago Press, 1964.

Wroth, William. *Christian Images in Hispanic New Mexico.* Colorado Springs: The Taylor Museum, 1982.

The Impact of European
Prints on the Devotional Tin
Paintings of Mexico:
A Transferral Hypothesis

Yvonne Lange

Lithography was invented in 1798 by Aloys Senefelder, a Bavarian. Lithography is a planographic process, which distinguishes it from the relief and intaglio processes that had dominated pictorial printing until the early nineteenth century. As a versatile and inexpensive means of multiplying drawings, lithography rapidly gained popularity in Europe. It was successful in America by 1825[1] and was introduced to Mexico in 1826 by Claudio Linati, an Italian artist with Parisian training.[2] Chromolithography, also a Senefelder innovation, was in wide use in Europe as a reproductive color process by the 1840s, with its heyday occurring in the second half of the nineteenth century.

By about 1820, European commercial printers were producing floods of lithographed devotional prints. Industrialization brought a radical increase in the quality of prints available to the worldwide markets the European Powers had established during the colonial era. In order to boost sales, European printmakers went so far as to set up branches of their own overseas, notably in the United States. A case in point is Carl Benzinger and Sons, which had been operating since 1792 in the pilgrimage town of Einsiedeln in Switzerland and implanted itself in Cincinnati as early as 1838. Benziger Brothers, as the enterprise later came to be known, evolved into the most important Catholic publishing house of books, almanacs, and religious prints in the United States, with additional branches in St. Louis, New York, Chicago, and San Francisco. In Mexico, as elsewhere, local competitors also did not hesitate to exploit the lucrative print market by setting up their own lithographic shops with the dual function of printing and publishing. European compositions were pirated or adapted, a practice that persists to this day despite copyrights.

Art historians have long recognized two factors having significant impact on the content and style of ecclesiastical painting, sculpture, and architecture in colonial Mexico (1519–1821). The first was the control exercised by the church to ensure that artists would conform to

the regulations governing sacred art drawn up in 1563 by Session XXV of the Council of Trent, held in response to the Lutheran Reformation, and by the Mexican Synodal Councils, chiefly those of 1555 and 1585.[3] Church authorities were empowered to order the elimination of any religious representations that did not conform to the prescribed standards. The second factor was the heavy reliance of artists on European prints (woodcuts, copperplate engravings, and etchings) as models and sources of inspiration.[4] One source, the Plantin Press in Antwerp, *prototypographus regius* (printer to the King), supplied Spain from the time of Philip II (1556–1598) with bibles, religious texts, and devotional prints by the thousands. Substantial numbers of these found their way to the New World through exports from Seville and Cádiz.

This article will focus on the devotional tin paintings of Mexico, exclusive of *ex-votos*, in an effort to discern the impact of popular prints on their subjects and styles. It is important to note that the tin paintings are predominantly the work of folk painters capable of emulating academic and popular sources. Because the paintings essentially were intended for home veneration, they escaped ecclesiastical control, a situation that favored unintended innovation on occasion. It is striking that by and large their content nevertheless is an accurate reflection of prescribed Christian iconography, despite the complexity of its symbolism. Such iconographic consistency excludes the possibility of parallel invention and can be explained only by reliance on sources that were accessible not only to the tin painters and their patrons, but also were cheap and easily transportable to the artists' workplaces. The devotional prints produced abroad and in Mexico fit these requirements, since a great variety of depictions were sold in the religious supply stores commonly found near centrally located churches, in market stalls, and at the innumerable shrines of Mexico. This is not to deny that painters also could avail themselves of the more limited subjects represented in their local churches. The *Mano Poderosa* or *Brazo Poderoso* (The All Powerful Hand/Arm of Christ), however, is one composition that is absent from churches but commonly found in tin paintings.

A survey of tin paintings will show an emphasis on popular Mexican shrine figures, but just as importantly it will be apparent that their content also reflects many religious devotions that were celebrated by Roman Catholics in Europe by the early nineteenth century.

The tin paintings center on events in the life of the biblical Christ, especially His Passion and redemptive mission; christological devotional representations such as the Arma Christi (Arms of Christ, or Instruments of the Passion) and the Eucharistic Man of Sorrows; and shrine paintings and sculptures of Christ bearing His Cross that are venerated at specific pilgrimage sites in Mexico. Until Mexico's 1857 constitution, which was initiated by the liberal Zapotec Indian President Benito Juárez and abolished the special privileges of the church and the military, it was common practice to carry such Passion figures in public processions during Holy Week. For that reason, they were known as *paso* figures.

Marian devotions abound in Mexico. They range from those promoted by the major missionary orders, including their nunneries, such as the Immaculate Conception, Our Lady of the Rosary, Our Lady of Mount Carmel, and Our Lady of Ransom (La Merced) to figures venerated at major shrines, such as Our Lady of Guadalupe, Our Lady of San Juan de los Lagos, and Our Lady of the Rosary of Talpa. Nineteenth-century popular European pilgrimage figures also are

represented, such as Our Lady of Lourdes and Our Lady of La Salette.

Archangels and saints who exercise intercessory or protective functions are very popular, although female saints are fewer in number than male saints owing to the fact that the church has canonized a greater number of the latter.

Except for three New World saints, one from the Franciscan Order, St. Felipe de Jesús, a native Mexican, and two from the Dominican Order, the Peruvian St. Martin de Porres and St. Rose of Lima, who was born in Puerto Rico but migrated to Peru at an early age with her parents, all the saints depicted are from the Old World and have been the subject of widely distributed prints.

Two devotions related to the salvation of the soul are firmly implanted in Mexico and have had a long history in Roman Catholic countries. They concern a Happy (or Holy) Death and the Souls in Purgatory, and they are directly accountable for the popularity of certain saints both in Europe and in Mexico.

A Happy or Holy Death refers to death in a state of grace, that is without the stain of mortal sin that would condemn one's soul to eternal punishment in Hell. Catholics have a great fear of dying without the benefit of the Sacraments of the Church, especially that of Penance whereby the sins that have been committed since Baptism are forgiven. The Happy Death devotion gained momentum in 1648 when the Jesuits established a Confraternity, headquartered in Rome: "A pious association of the devout Servants of Our Lord Jesus Christ, dying on the Cross, and of the most Blessed Virgin Mary, in order to obtain a happy death" for oneself and for fellow-members.[5] Since St. Joseph had the exceptional privilege of being attended by Christ and the Virgin Mary at death, he is the first and foremost patron of a Holy Death. Another powerful advocate is St. Jerome, who is invoked as "Defensor de la Fe y abogado para la buena muerte" (Defender of the Faith and Intercessor for a Holy Death). St. Camillus de Lelis, founder of the Order of Clerics Regular, Servants of the Sick, is popular in Mexico (No. 46). He is a frequent subject in tin paintings that are graphic in their complex depictions of the dying and the last rites as a means of wresting the soul from the clutches of Satan and the evil spirits. Among the Fourteen Holy Helpers or Fourteen Auxiliary Saints, who are honored as a group, the most powerful are those whose intercession is of particular significance at the hour of death: Giles, who ensures a good confession; Achatius, who dissipates the fear of death; and Christopher and Barbara, who guarantee that no sinner will suffer a sudden death, thus depriving him of a last opportunity to make peace with God.

Regarding the second devotion, purgatory is where, prior to gaining entrance to heaven, souls suffer for a time in atonement for their sins. According to the Scriptures, "nothing defiled shall enter heaven; some will be saved 'yet by fire.'" The Roman Catholic Church believes that the faithful on earth are in communion both with the saints in heaven and with the souls in purgatory through prayer. Prayers and the good works of the faithful help the souls in purgatory to gain their release. "It is a holy and wholesome thought to pray for the dead that they may be loosed from sins." This deeply held belief is reflected in a side chapel that was consecrated to the Souls in Purgatory in a great majority of churches in Catholic Europe, at least from the Council of Florence of 1439,[6] and in the New World from the early days of the Euro-

pean Age of Discovery. Special masses are offered here for the repose of the souls in purgatory, and deep concern for the salvation of one's soul and those of family members is also manifest in countless wills that provide for masses to be said on thirty consecutive days. To this day it is customary for family and friends to make cash offerings to parish priests for masses to be said on anniversary dates and on November 2, the Feast of All Souls, known in Mexico as Día de los Muertos. This commemoration, combining as it does ancient Indian beliefs of communication with the dead and Christian traditions, is perhaps the most popular and widespread celebration throughout Mexico. It involves, among several activities, church and domestic rituals, the cleaning and adornment of graves with flowers and lights, home altars, and special foods.

The most graphic evidence for the depth and breadth of the devotion to the Souls in Purgatory is to be found in the Mexican tin painting. Among the representations of the Virgin that were promoted by the missionary orders, there are four principal ones that show Mary in her role as intercessor for the Poor Souls. These are Our Lady of Mount Carmel (Carmelites), Our Lady of the Rosary (Dominicans), Our Lady of Light (Jesuits), and Our Lady, Refuge of Sinners (Jesuits). The Franciscans popularized the *Arma Christi,* which is a depiction of Christ Crucified surrounded by the Instruments of the Passion that caused His suffering. This christological representation was considered in the Middle Ages to have magical powers, and has become highly personalized in Mexico, where it takes on the name of *Cruz de Animas* (Cross of Souls) because half-figures of young females and bearded males with naked torsos, lined up at the foot of the Cross, represent souls amidst the flames of purgatory (No. 38). In addition to the family name the soul of each of its deceased members is carefully identified by name. The work is a collective and visual record of those who have predeceased the living members of the family, who are reminded to pray for the repose of their souls. The Dominican Saint Nicolas of Tolentino, patron of the dying and of the souls in purgatory, is represented in the tin paintings but not as frequently as the advocates mentioned above. Another highly popular devotion is that of the Ánima Sola, or The Most Neglected Soul in Purgatory, who is depicted as a beautiful young woman with manacled hands, incarcerated in a grilled cell engulfed in flames. On occasion, the soul takes on the features of a tonsured monk. Both figures appear half-length with naked torso.

The hagiography of the tin paintings show the extensive transfer, through the medium of religious prints, of Old World devotions and beliefs to the New. This observation is confirmed by fieldwork in Mexico[7] and by comparison with the increasing number of illustrated books on nineteenth- and twentieth-century religious imagery being published by European scholars.[8] Their research is sparked by interest in social attitudes that have been changing since the French Revolution. This interest has been growing steadily over the past twenty years and has even spread to the Americas, as witnessed by pioneering investigations in Canada.[9]

While the emphasis in this essay is on prints, it should be mentioned that there are other factors that also influence popular religious representations in overseas countries. Briefly, these factors have to do with demographics, religious orders, and trade. Demographics involve the socio-political events that promote major migrations and shifts in population trends. The ethnic composition and religious background of the population is also a consideration. Obviously

migrants travel with their beliefs and introduce them where they settle. The presence of specific devotions in a particular area can be traced to the religious orders that are known to promote them. And the external and internal communications that make up trade relations among countries also facilitate the distribution of religious prints.

From the European Age of Discovery sailing ships maintained direct and sustained links between Mexico and Spain. Under the impulse of revolutionary movements in Latin America in the early years of the nineteenth century, Spain was forced to relax her stifling overseas trade and immigration policies, which brought Mexico into more direct maritime contact with other European countries. The immediate consequence of Mexico's independence from Spain, proclaimed on August 24, 1821, was the opening of a direct overland trade route with the United States. Regular commerce was established via Santa Fe, the capitol of New Mexico since colonial times. Soon goods were being freighted by wagon and mule train from Santa Fe to the rich silver mines of northern Mexico via the Chihuahua Trail, which, in effect, was the southern extension of the Santa Fe Trail. The trail remained operative until the advent of the railway in New Mexico in the early 1880s.

It is now time to pose the question: Is the impact of European prints and their Mexican derivatives on tin paintings limited to religious devotions and their representations? To find the answer, we may now turn to the illustrations. I suggest that there are three distinct stylistic types to be found in the tin paintings, which, based on their most salient characteristics, I have labeled as follows:

> Type A, based on West European Renaissance painting (No. 73)
> Type B, based on European Glass painting (No. 20)
> Type C, based on Near Eastern Icons (No. 15)

Type A, the European or Western type, is broadly defined as naturalistic with rounded, modeled figures and soft lines and colors. The chief characteristics of Type B, or the Glass Painting type, are half-figures that are proportionally larger that those of the West European or Near Eastern iconic types; a profusion of flowers as saints' attributes, crowns of female saints, and background decoration; and fluffy white clouds. Colors are vivid. Type C, or the Iconic type, is characterized by thickly outlined, linear figures (hands and fingers included) with large almond shaped eyes, rectilinear eyebrows, and long noses. Frequently an uninterrupted thick line forms one eyebrow, descends to outline the sharp nose and stops to delineate the second eyebrow. The six-pointed star, the eight-pointed star, and dots are decorative features of background and appeal that are shared by all three types. Also, on occasion, Types A and C display a frame-filling half-figure. This feature, however, when associated with clouds and a profusion of flowers in crown and background, establishes Type B.

The decision to name Type B the Glass Painting type is not arbitrary; this designation stems from comparisons of the body of Mexican tin paintings with reverse paintings on glass from other parts of the world that reveal striking shared features.

When Mexicans use prints with West European characteristics as models, they produce tin paintings with those same features. Accordingly, with regard to the tin paintings that reflect the characteristics of the Glass Painting and Iconic types (B and C), it is unlikely that local

painters reinvented such features independently. The technique of reverse painting on glass does not seem to have been applied to religious subjects in Mexico, although it has been used for the decoration of frames with floral motifs (No. 68), which are reminiscent of the flowered borders of wood that came from the Low Countries.[10] Further, there is no evidence at present of European glass paintings with religious representations having been introduced into Mexico. Accordingly, I formed a strong suspicion that in the absence of domestic prototypes, the artists would have to have had access to model prints reflecting the characteristics of the last two types. From where could such prints have come? The search for an answer led to two theories that triggered an inquiry into the field of religious lithographic prints—a largely unexplored field that has not yet been the subject of systematic study. The preliminary results reported here, therefore, can only be termed tentative.

The first theory concerns Iconic Type C. In 1986, my research in major print depositories in France and at the Benziger firm in Switzerland consistently turned up West European type prints. Consequently, I turned my attention to Italy, whose art, especially that of its eastern and southern regions, was heavily influenced by Greece. But here a major difficulty was encountered: geographic fragmentation of archives stemming from the fact that it was not until 1861 that several independent Italian states and kingdoms formed a politically unified nation. I encountered a wide regional distribution of archival holdings controlled by civil and religious authorities and by commercial manufacturers of prints. Where was a researcher to start looking for promising repositories of popular prints, which already are notoriously ephemeral? Owing to the high concentration of printmakers in Milan, I made a brief visit to that city in the fall of 1986. As reported elsewhere,[11] one serendipitous result was the location of the multilingual, highly illustrated *1988 Trade Catalog and Price List* of religious prints and holy cards, with a special insert headed "Immagini Serie 'Icone' cm. 7 x 12 su cartoncino," published in Italian, English, French, and Spanish by Edizioni Grafiche Isonzo Milano.[12] At the time of writing this article, another fortunate event occurred. A 1958 trade catalogue put out by the German firm KAMAG (Kunstanstalten May A.G.) of Fürth, Bavaria, turned up at El Paso, Texas.[13] The catalogue offered a wide range of illustrated religious prints and holy cards in various sizes and targeted an international export market, judging from the fact that descriptions and price lists are in four languages, German, English, French, and Spanish. The great surprise was to find that a number of the prints are Iconic or Byzantine in style and content, as they depict saints venerated in the Eastern Orthodox Church. These two trade catalogs are patent evidence that imagery in both West European and Iconic styles has been emanating from Italy and from Germany. Research is yet to establish whether such a dual graphic tradition of publishing extends to other countries, and whether its age stretches sufficiently far back into the nineteenth century so that it is contemporaneous with religious representations that in Mexico, New Mexico, and Venezuela, among other countries, exhibit the iconic characteristics of Type C. Were such a fact demonstrated, it would go a long way towards explaining the simultaneous existence of the specific stylistic features of Type C in divergent geographic areas overseas.

The second theory, which was formulated only very recently, concerns the Glass Painting type. This theory holds that: (1) devotional paintings on glass were reproduced in Europe by

chromolithographic and photochemical processes for mass distribution as prints and post-cards; (2) very likely facsimiles of devotional paintings on glass were imported into Mexico by local printmakers and religious supply stores; and that (3) Mexican painters used such fac-similes of European paintings on glass as their source of inspiration, which would account for the resemblance between those Mexican tin paintings displaying the characteristics of Glass Painting Type C and the European paintings on glass.

Among those countries with a tradition of painting on glass are Germany, Austria, Czecho-slovakia, Poland, Roumania, Italy. Here again, the geographic distribution of potential sources is very wide. Other than making a preliminary survey of available publications on glass paint-ings in Europe, in-depth research has yet to be undertaken. One benefit, however, from the profound political changes that have occurred lately in Europe undoubtedly will be that Ameri-can researchers will have greater access to Eastern European scholars and archival resources.

The research that has been outlined in this essay, some of which still is very much in a preliminary stage, points to the following conclusions. The nineteenth-century rustic painter is no different from artists who sought inspiration in religious prints from the dawn of the Renais-sance. The industrialization of printmaking in the nineteenth century did not break that tradi-tion; on the contrary, it reinforced it. It must be recognized that, owing to their heavy depen-dence on graphic models, folk painters are essentially copyists. Accordingly, traditional concepts regarding the uniqueness of individual works and the notion of artistic creativity are brought into question by the tin paintings of Mexico. Art historians whose preoccupation is attributing a body of work to a particular artist based on individual style should take into account the influence of the ubiquitous lithographic print. This is not to deny that artists do imprint their individuality on their works by the manner in which they interpret their source material and handle the tools of their craft.

Regarding the dating of tin paintings, especially in the absence of biographical informa-tion on the artists who painted them, it is unwise to judge age solely on the basis of stylistics. There may be a built-in time lag in the notoriously conservative nineteenth-century popu-lar religious prints, which frequently reflect long-abandoned elite styles such as the baroque, rococo, and neoclassical. On the other hand, the alert art historian will find reliable indicators based on historical evidence. Depictions of Our Lady of the Miraculous Medal, Our Lady of La Salette and Our Lady of Lourdes, for example, cannot have been painted prior to 1830, 1846, and 1858, respectively, because these are the years the Virgin Mary is said to have appeared at those shrines in France.

Nineteenth-century graphic source materials, misinterpreted sometimes by the printmaker and sometimes by the painter or sculptor, escaped church control, thus leaving room for cre-ativity and unintended innovation, which on occasion even gave rise to new religious depic-tions and new devotions. Such is the case of El Santo Niño de Atocha, a highly popular devo-tional figure of the Christ Child in Mexico,[14] and the Virgin of Hormigueros in Puerto Rico.[15] I also think lithography brought about technological change in the making of religious imagery in New Mexico, causing the flat, two-dimensional painted panels and a new emphasis on three-dimensional sculpture.[16]

The tin paintings of Mexico are a window on past values. They are pictorial records of popular religious devotions practiced in Mexico throughout the nineteenth century and well into the twentieth, despite political upheavals and policies aimed at restricting church influence. They also communicate visual information about popular culture, reflecting as they do the continuum of Roman Catholic beliefs and traditions, some of which go back to the Late Middle Ages and the Counter-Reformation.

The tin paintings of Mexico have received limited attention from scholars in the United States[17] and little, if any, from Mexican researchers. The neglect of this form of popular art may be explained partially by the fact that Mexican colonial religious art, considered of greater cultural significance, takes precedence in the academic world.

The tendency among art historians and critics has been to judge devotional prints and drawings that pre-date the advent of lithography in 1798 as worthy of study among the so-called fine arts but to consider subsequent lithographic prints undeserving of scholarly attention on the basis that they are devoid of artistic merit. Though this attitude might be justified on elitist aesthetic grounds, it has led investigators to neglect this body of material, a valuable source for documenting, among other things, cultural changes from the influx of new elements and the loss of existing ones; artistic creativity; popular religion; socio-economic values; migration and settlement patterns; and currents of trade.

It is hoped that this essay will demonstrate that devotional prints are a legitimate field of study, for no matter what technique was used to produce them, they have had a great artistic and social impact. European scholars are opening promising perspectives in this new area of inquiry, to which researchers of Iberian material culture, the Hispanic Southwest of the United States included, also have an opportunity to make valuable contributions. Popular prints as prototypes for religious folk art in the New World is a wide-open field that beckons new research.

I owe a debt of gratitude to Richard E. Ahlborn, curator, National Museum of American History, Science, Technology, and Culture, Smithsonian Institution, for judicious guidance and critical appraisal of this essay.

NOTES

1. David Tatham, ed. *Prints and Printmakers of New York State, 1825–1940* Syracuse: Syracuse University Press, 1986, 8.

2. Edmundo O'Gorman, ed. "Documentos para la historia de la litografía en México," *Estudios y Fuentes del Arte en México*, no. 1 (Mexico, 1955), 65.

3. Elisa Vargas Lugo, "La expresión pictórica religiosa y la sociedad colonia," *Anales del Instituto Nacional Autónoma de México*, no. 50/1 (1982), 55–60.

4. Jorge Alberto Manrique, "La estampa como fuente del arte en la Nueva Espāna," *Anales del Instituto Nacional Autónoma de México*, no. 50/1 (1982), 55–60.

5. "Confraternity of the Happy Death" (Rules). [New Orleans: s.n., 1875]. Devlin Papers, Historic New Orleans Collection, La.

6. Gaby et Michel Vovelle, "Vision de la mort et de l'au-delà en Provence d'après les autels des âmes du purgatoire XVe-XXe siècles." *Cahiers des Annales*, Paris, no. 29 (1970), 10.

7. Gloria Fraser Giffords, "Mexico's Last Saint Makers," *El Palacio* 83, no. 3 (fall 1977), 10–27.

8. *France:* Catherine Rosenbaum-Dondaine, ed. *L'image de piété en France: 1814–1914.* Paris: Musée-Galerie de la Seita, 1984. Alain Vircondelet, *Le monde merveilleux des images pieuses.* Paris: Editions Hermé, 1988. *Germany:* Christa Pieske, *Bilder für jedermann. Wandbilddrucke 1840–1940* Munich: Keysersche Verlagsbuchhandlung 1988. *Italy:* Achille Bertarelli, *Le stampe popolari Italiane.* Milan: Biblioteca Universale Rizzoli, 1974. *Low Countries:* Maurits de Meyer, *Imagerie Populaire des Pays-Bas.* Milan: Electa Editrice, 1970.

9. Pierre Lessard, *Les petites images dévotes. Leur utilisation traditionnelle au Québec.* Quebec: Les presses de l'Université de Laval, 1981.

10. In the second half of the nineteenth century, facsimiles of prints with floral frames from earlier centuries were chromolithographed in Belgium and elsewhere, as one aspect of the Gothic Revival.

11. Yvonne Lange, "In search of San Acacio: The impact of industrialization on Santos worldwide," *El Palacio* 94, no. 1 (summer/fall 1988), 18–24.

12. I am indebted to Joseph Sciorra, folklore researcher and consultant in Brooklyn, New York, for providing me with a copy of this catalogue.

13. A 1958 German trade catalogue on holy cards in the possession of Francis Tolland of El Paso, Texas. The contribution of Dr. Christa Pieske in identifying the publisher is gratefully acknowledged.

14. Yvonne Lange, "Santo Niño de Atocha: A Mexican Cult Is Transplanted to Spain," *El Palacio* 84, no. 4 (winter 1978), 2–7.

15. Yvonne Lange, "Lithography, an Agent of Technological Change in Religious Folk Art: A Thesis," *Western Folklore* XXXIII, no. 1 (January 1974), 51–64.

16. *Ibid.*

17. Gloria Kay Giffords, *Mexican Folk Retablos,* 2nd ed. Tucson: University of Arizona Press, 1979.

An Introduction:

The Context of the

Mexican Retablo

Virginia Armella de Aspe
and Mercedes Meade

Religious paintings and engravings of the Middle Ages document the principal themes of the Catholic religion and represent scenes from the life of Christ and the twelve apostles, chapels and altars dedicated to the Virgin Mary, and the saints with their various attributes. Because of their low cost, small wooden engravings on paper were particularly common and easy to preserve. The owner would glue them to pieces of leather or cloth, consequently certain representations achieved popularity and helped establish traditional characteristics. The saints were recognized by their attributes: St. Peter would carry two large keys and St. Paul, a sword; St. Jerome was represented half-naked in the interior of a cave with a lion lying at his feet and a celestial coronet, which from on high would inspire his writing through insufflation; St. Barbara held a castle in her hand; St. Augustus, dressed as a bishop, carried a miniature church; and so on.

These primitive engravings thus originated a good part of the religious iconography that endures to this day. As time passed, new saints and devotions were added to the iconographic heap of the Middle Ages, and as they emerged and their images were painted, they became codified and little or nothing would vary in their representations so the faithful easily could recognize them.

The Pictorial Tradition of Ancient Mexico

A very sophisticated pictorial tradition had existed since the pre-Hispanic era in Mexico, which we can appreciate in the painted murals and codices. This tradition is characterized by special aesthetic forms, with great expressive energy and originality in the composition and coloring.

During the conquest and conversion of Mexico, the Indians learned not only the teachings of the Catholic faith but also its iconography. The imagery was an extremely important teach-

ing aid because the teachers and students spoke different languages, and in the beginning the images took the place of words.

The Franciscan Fray Pedro de Gante founded a school for Indians in Mexico City where, among other disciplines, they taught painting classes. One of the friars, Fray Diego Valadés, wrote with admiration of the ease with which his pupils learned. A few years later, painters of Indian origin were creating their own images for the churches in their villages or in the barrios of Mexico City.

There were restrictions for painting the religious images, however. Pupils in the school of Fray Pedro de Gante, for example, would receive advice and supervision in the proper use of attributes in representing religious themes. Artists who wanted to dedicate themselves to painting as a profession would begin by apprenticing in the shop of a master teacher and pass through the three stages of the career, apprentice, official, and master, which permitted them to have their own shops and sell the works of others.

The masters would approve the finished paintings before they left the shop. The ensemble of masters made up the guild, established in 1557, and wrote the regulations governing quality of production, excluding from the profession whoever did not comply. The regulations established some concessions for the Indian painters: that they pay only half the amount (4 pesos) of the examination fee and that the examination would be based on only a part of their knowledge. They could not sell paintings, however, without prior approval. Passing the examination required knowing how to prepare the canvas and the colors—a difficult achievement because the colors were of mineral, animal, and vegetable origin. The candidate also was required to depict flowers, fruits, grottos, various kinds of fabrics, and a human figure both naked and dressed.

Few Indians became masters in the sixteenth century, and manuscripts mention only the most famous. Some who practiced the profession painted copies of devotional images for domestic altars. These were the first popular painters of religious images, the predecessors of those represented in this exhibit.

Most religious painting was designated for altarpieces, constructed of wood and coated with gold leaf, and designed to cover a wall or apse in a church. The altarpieces originated in the Gothic triptychs of the Middle Ages; later they became more complicated and were called polyptychs, an arrangement of hinged panels designed to hold more paintings. In the Renaissance it became the custom to cover completely the apse or rear wall of the church. Some of these altarpieces are flat, like large theater hangings; others are hinged to adapt to the wall they are meant to cover. The more modest churches have smaller altars, of course, and in all of these altarpieces the wooden framework leaves spaces for carved panels, paintings, or statues.

The popular devotions are manifested in the sanctuaries and churches where a miraculous image is venerated. Mexico's principal sanctuary, located in the north of Mexico City, is the Virgin of Guadalupe. The most famous image of Christ is the one in Chalma. As a sign of offering, pilgrims arrive at the sanctuary dancing. Among the most venerated saints is Santiago (Saint James), the patron of Spain, who is represented on horseback in the act of beheading Moorish soldiers, his pennant in hand. Sculptures of Santiago have all the characteristics of the

charrería, or Mexican riding horseback: a saddle, bit, stirrups, and reins. All the details are real down to the tail and mane. In the paintings, Santiago rides on an ingeniously painted horse that looks more like a donkey. Another saint who has many attributes is San Pascual Bailón, the patron of cooks. Pascual was in charge of preparing the food for his monastery. Every day he would have a celestial vision and fritter his time away praying. When meal time came and the food was not yet prepared, the angels would come down from heaven to help him. We still find numerous paintings of San Pascual designed for kitchens.

In 1783 the Academy of Noble Arts of San Carlos was begun in Mexico City. The outlines of neoclassical style were taught here, in classes on architecture, sculpture, gold and silver work, painting, and engraving. A few years later more academies opened throughout the province, which local painters attended to take painting classes. Few completed the courses, but they did receive a basic knowledge of drawing and instruction in the techniques of oil painting, watercolor, and engraving. This education was sufficient for many local artisans, who developed an original and independent form. Their creativity and freshness is evident in their portrayal of everyday life; in portraits of family members, landowners, the parish priest; merchants and their wives; street and equestrian scenes; still-lifes or kitchen scenes, then called *mesas revueltas* (intricate tables); and a series of *castas,* caste or racial types, dressed traditionally and engaged in typical activities, with local monuments or buildings forming the backdrop.

After Mexico's independence the guilds were suppressed and painters continued their activity independently. Examination requirements were dropped, and standards of excellence in the preparation of canvases and colors and the reproduction of religious images were suspended.

During this time there was an influx of industrial products to Mexico, such as tinplate, which the popular artisans adopted for their paintings for its resistance and economy. Tin did not have to be stretched on a frame like canvas and it was less expensive than linen, which also was imported from abroad. The paintings on tin as a rule were not meant to be altarpieces, but rather were designed to be free-standing and hung in private houses as mementos of venerated images or as *ex-votos.*

The tinplate frames that appear on some paintings, which are made out of the same material, indicate the abundance and ease of acquiring the material. At this time it was so abundant that the frames became traditional. Almost all originate from the last third of the eighteenth century and the beginning of the nineteenth century. The style is the last phase of the baroque, in some cases rococo or early neoclassic, interpreting the elements of their design in an ingenious form that corresponds to the paintings they contain.

Ex-votos are designed to express gratitude to a celestial being for working a miracle, and generally they carry an inscription that tells about the event. They have great documental value; through them we have become acquainted with the clothing, penmanship, and an endless number of details of daily life that were in vogue during the time they were painted.

The Art Historical Approach to Popular Painting

Popular art has only been studied seriously in this century. In 1925 the National Institute of Intellectual Cooperation, under the auspices of the League of Nations, called the first National Congress of Popular Arts in Prague. The definition of popular art that resulted from this congress refers to all popular artistic expressions in general. To quote Don Manuel Toussaint (1890–1955), one of the most distinguished Mexican art historians:

> During the eighteenth century, one of the most interesting manifestations of Mexican art surged with an unexpected force—popular painting. During the colonial period, it was referred to as common art. The paintings were done principally by Indians trying to imitate European painting. Generally without schooling, these painters would insert whatever their aesthetic instinct would dictate to them. . . .
>
> [Popular artists] are generally anonymous village people who paint for their community. Because their work is the aesthetic expression of the village, we have an idea of how the village perceives a particular deity. When an artist reproduces the Plaza Mayor in Mexico, he gives us a view of the plaza as it was seen by his contemporaries. In an *ex-voto* we seem to be able to hear the very one who gives thanks. The popular artist is only the interpreter, and he disappears after the work is completed. The popular artist interprets the experience of the village, from which the art derives its notable spontaneity. Popular art has aesthetic purity. There is no school prejudice. The popular artist has not been taught to see, nor how to paint what he sees. His pictorial sense is forged with his own personal aesthetic formulas. Each artist possesses a special technique and the resulting works are as varied as the individuals who create them.
>
> Popular painting produced four types of works in Mexico: *Ex-votos*, sometimes called *retablos;* pictures of typical, popular, or historical scenes, or sites known by the artist; images of saints; and portraits.
>
> There were also mural paintings adorning the pulque shops, stores, earthenware jars, and other parts of the haciendas, many of which have disappeared.
>
> Assaults, wars, fires, illnesses, falls into the well or into a ravine—everything is reproduced in the *ex-votos* and, in a corner, among clouds, appears the image of the almighty, who was invoked in a moment of faith by the fervor of a frightened soul and who performed the miracle for the supplicant.
>
> In these pictures we see great ingenuity and in many of them surprising vigor.

And elsewhere Toussaint observed:

> The anonymous, popular saints are characterized by a rudimentary technique in their faces and hands; well-painted canvases; an abundance of gold applied to their clothing and accessories; female figures whose dress suggests that of Indian women; and portraits exaggerated to the point of caricature.

It is notable that in all these paintings expressions of popular religiosity frequently remind one of the primitive Italian or Catalan paintings and German engravings.

Among the outstanding non-religious paintings are those that depict Mexican customs, such as the market stalls with all the fruits and vegetables the earth produces, and the interior of the "parian," the building constructed on the plaza to house the Chinese merchants and other locals who traded. In its interior were sold arms, furniture, gold and silver work, culinary delicacies, shoes, and so on, and at the same time the paintings depict all the different types of people that passed through the plaza: Indians, blacks, military men, clerics, muleteers, all kinds of peddlers, the viceroy and his retinue, and even a pickpocket.

Popular portraits generally represent the model posing face forward or with the head tilted slightly to one side. Great care is taken to achieve a realism in these drawings. Children were frequently portrayed on their death bed, surrounded by flowers, or dressed in finery as in life but with their eyes closed. Others appear to be part of an allegorical scene, arriving in heaven hand-in-hand with their guardian angels or being received by the Virgin or a patron saint. These are more festive because they have life and movement. Other portraits painted during the Wars of Independence depict military attributes, and the models are frequently uniformed.

The historian of nineteenth- and twentieth-century art, Justino Fernandez, wrote about popular painting:

> The tradition of popular painting, especially religious painting, originated in the sixteenth century. Not only in Mexico, but in the rest of the world, popular art has been reappraised. Now then, how does one distinguish popular art from art in general?
>
> Art is the beautiful expression of a historical consciousness. A beautiful, harmonious expression, capable of eliciting an emotion or a spiritual disturbance that reveals something.
>
> Popular art also elicits emotion or spiritual commotion, but it lacks historical consciousness. The popular artist does not know where his expression is located in historical time. He paints simply because he likes to.
>
> Popular painting is characterized especially by the color, the sensation of its forms, by many of its themes, and by its spontaneity.

About the *ex-votos* Fernandez offered:

> In addition to the characteristics of popular painting, spontaneity and charm and fantasy intervene, giving an unreal aspect to the *ex-votos* that synthesizes this world and the hereafter. The *ex-voto* evidences the miracle or divine favor received in an unfortunate circumstance, and the themes are infinite. Sometimes these are various scenes depicting involvement with the image of the celestial savior that result in an ensemble of fanciful interests and reveal the faith that works miracles: the fantasies are treated as absolute realities. They are spontaneous: the composition, the individual forms, the color, the explanatory narratives that appear in the lower portion of the picture. They are sentimental

compositions. They sincerely want to express the event. They have spontaneity and charm. The Mexican *ex-votos*, essentially like the French, correspond to the same type of expression, with the same traces of all popular art, in addition to the religious intent. In the *ex-votos*, the village bursts into the painting in a dramatic way, as much by the circumstances depicted as by the religious faith infused in it.

Popular painting is an authentic expression of the life of our grandparents, in which one notes the absence of the politics of the time, anything that did not have an interest or suitability in the intimacy of bourgeois and religious life, although there are some pictures that represent notable occurrences.

Roberto Montenegro, a learned Mexican painter who lived for several years in Europe, made famous portraits in the art-deco style. Upon his return to Mexico, he collected pieces of handicrafts and popular paintings, and organized an exhibit and accompanying text in which he saw many parallels between popular Mexican painting and the French naïve painter Henri Rousseau.

Because he knew how to withdraw from the influences, he remained himself, within himself, considering nature and the events as the basis for expressing his way of being and feeling.

These same qualities are found in our painters of the first half of the nineteenth century. . . . We should remember that a great number of anonymous artists did not sign their pictures because of forgetfulness or modesty, and in spite of the accidents they have bequested to us valuable samples of the painting from the first half of the nineteenth century.

Perhaps it was the painter Gerardo Murillo, who called himself Dr. Atl, who was the first in Mexico to make a systematic study of the popular arts. His book *Las Artes populares en México* (1921) offers an interesting comment on the art of decoration. The members of traditional societies

have always been great decorators. . . . By decoration I mean the tendency to organize lines and colors within a geometric balance to make a work of art—whether on a wall or a drinking glass, or in the haphazard adornment of a church or house. The Mexican Indians are logical in their decorative concept; they develop it harmoniously, whether decorating a bowl, knitting a serape, or adorning a church for a saint's festival. They paint their houses . . . in harmony with the scenery; they arrange the stalls where they sell their wares with a refined taste; they design their gardens with an art full of poetry; their altars to glorify the saints are magnificent pictures of color, and their floral arrangements in church harmonize with the architecture . . . In their novenas to a famous image, in all their religious celebrations in general, the inhabitants of the villages adorn the streets with garlands and wreaths and give to them an aspect of joy, to which in great part truly con-

tribute the splendor of the sun and the clarity of the sky, these first and marvellous decorators of the earth.

As a final word on aspects of popular art, we have some comments of the painter Diego Rivera that refer especially to two painters of popular scenes who became known through the graphic arts. Rivera here distinguishes between popular art and fine art:

In Mexico there always have existed two currents of art production, truly distinct . . . the better known has been the work of the people and it engulfs the sum of the production, pure and rich, which has become known as "popular art."

The publisher Vanegas Arroyo, one of the most important in the Republic of Mexico, printed prayers, lives of the saints, accounts of crimes and miracles, legends, political commentaries, and humorous observations, all in the popular style on sheets of colored paper, for which the villagers would pay one or two cents apiece. Peddlers would sell them on street corners, in the markets, at fairs, and at ranches and haciendas. For the villagers, the majority of whom could not read, the illustrations were very important because they conveyed an idea of the event depicted.

When Manuel Manilla was the illustrator the religious tradition picured on these sheets, with their romantic colors and thick typographical characters completely overshadowed the illustrations. When Jose Guadalupe Posada began to work for Vanegas Arroyo, he relegated the text to second place and gave the engraved copper plates (lámina) the principal spot. This was a great financial success for the publisher.

Antonio Vanegas Arroyo was born in Puebla in 1852, the same year as Posada. He arrived in Mexico City in 1867. He first opened a bookbinding shop and, in 1880, the printshop that would later become the largest publisher of popular art in the country. He wanted to take culture to the masses. . . . Manilla was one of the most important forerunners of Mexican engraving. He gave to the form and content of his works the essential qualities of a national art and created a technique that Posada would later surpass. Both demonstrate that Mexican art has a special style. The artists are realists in the details but imaginative overall. It is in the internal structure of the compositions, in the movement of their forms, that the art has a balance and strength. It has vigor, movement, and geometry. The form was subordinated to the theme and the free style was a way of expressing the artist's intent in the best way. Posada represents in Mexico the beginnings of a social tendency in art. His art was produced in a moment of crisis; with Posada the feeling of genuine nationalism appears in the field of professional art. . . . Popular art has a social meaning that reaches the masses.

SELECTED BIBLIOGRAPHY

Bompart, Gabriel. *Religiosidad popular.* Folklore de Mallorca. Folklore de Europa. Prologue by Julio Caro Baroja. No. 34 de la Col. Archivo de Tradiciones Populares. Jose de Olanera, ed. Palma de Mallorca, 1982.

Fernandez, Justino. *Arte Moderno y Contemporáneo de México.* Prologue by Manuel Toussaint. México: Imprenta Universitaria, 1952.

———— *Arte Mexicano.* Desde sus Origenes hasta Nuestros Dias. Editorial Porrua, S.A. Mexico, 1958.

Martinez Penaloza, Porfirio. *Arte Popular y Artesanias Artisticas de México.* Ministry of Finance, Mexico, 1972.

Murillo Gerardo (Dr. Atl, pseud.) *Las Artes Populares en México.* México: Librería México, 1921.

Montenegro, Roberto. *Pintura Mexicana, 1800–1860.* Mexico, 1933.

Rivera, Diego. *Jose Guadalupe Posada, Artista Popular.* Artes de México. Primera Epoca, 4, year 6, no. 21, 1958.

Romero de Terreros, Manuel. *Las Artes Industriales en la Nueva España.* Librería de Pedro Robredo, Mexico, 1923.

Tablada, José Juan. *Historia del Arte en México.* Cia. Nacional Editore "Aguilas" S.A., Mexico D.F., 1927.

Toussaint, Manuel. *Arte Colonial en México.* Imprenta Universitaria. U.N.A.M., 1974.

———— *La Pintura Colonial en México.* U.N.A.M. 2nd edition, 1982.

Catalogue

of the

Exhibition

Gloria Fraser Giffords

1. *See Plate I*
ALTARPIECE

UN RETABLO

21¾ x 13¾ in.
55.24 x 34.9 cm.
Henry C. Lockett III

The images on this piece are arranged like
an altarpiece in a church. Figures are set
in niches (*nichos,* or *cajas*) and arranged
in vertical and horizontal divisions (*calles,*
bays; and *cuerpos,* registers or stories).
The *retablo* contains the lateral symmetry
of an altarpiece, with figures of saints and
archangels balanced on either side. The
predella, or bottom level, is filled with fig-
ures of the Souls in Purgatory while the
center contains, from the bottom up, God
the Father holding the dead Christ, with
the Veil of Veronica; the Immaculate Con-
ception; the Trinity; and the archangel
St. Michael. Set in little medallions are the
heads of male and female saints.

2. *See Plate II*
THE TREE OF DAVID

EL ARBOL DE DÁVID OR
LA PARENTELA DE JESÚS

13⅞ x 10 in.
35.2 x 25.4 cm.
Private Collection

The Tree of David or the geneology of
Jesus illustrates the imagined geneology
of Christ. Based on the prophecy of
Isaiah, King David is shown playing his
harp while a tree grows from his body.
The figures in the tree here are Jesus,
Mary, Joseph, Ann, and Joachim.

3.
THE TRINITY

LA TRINIDAD

14 x 10 in.
35.5 x 25.4 cm.
Sallie Griffis Helms

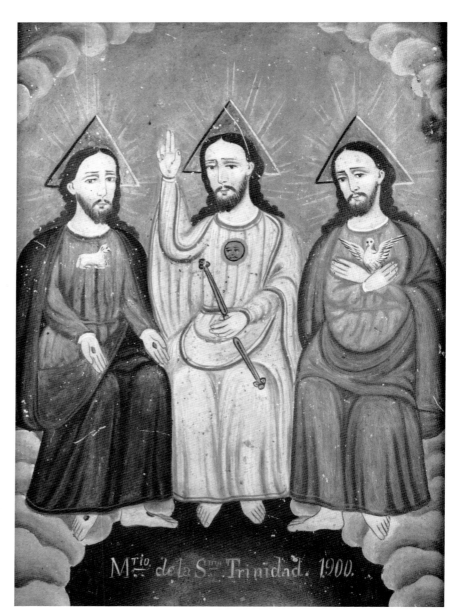

3.

4.

THE TRINITY

LA TRINIDAD

14 x 10 in.
35.5 x 25.4 cm.
Carroll Collection

The central dogma of the Catholic Church—the concept of three persons incorporated in one God—was portrayed as three identical men distinguished only by gestures or attributes, long after this representation was forbidden by Pope Benedict XIV in 1745. God the Father is shown in the center with the scepter; God the Son is seen with the stigmata and a lamb on his chest; and God the Holy Ghost is distinguished by the dove. Note the use throughout *retablo* art of red, white, and blue for these figures.

5.

THE OMNIPOTENT POWERFUL HAND

LA OMNIPOTENTE MANO PODEROSA

14 x 10 in.
35.5 x 25.4 cm.
Mr. and Mrs. Charles Campbell

The symbolism of the Omnipotent Powerful Hand can be traced to the introduction of the cult of St. Ann by crusaders returning from the holy lands. Relics of Ann included a hand-shaped, bejeweled reliquary known as the Anna-hand. Through an evolution of ideas another element was added, the hand of Christ. The wounded hand spurts blood into a chalice from which lambs drink, a Eucharistic theme that here is accompanied by symbols of the Passion.

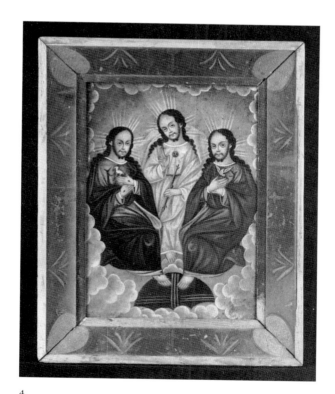

4.

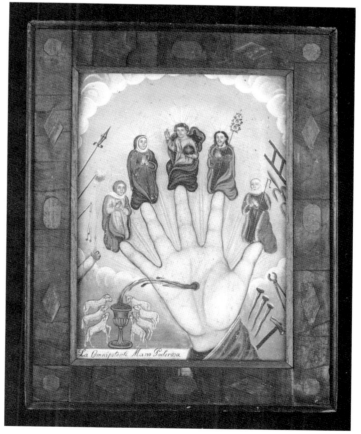

5.

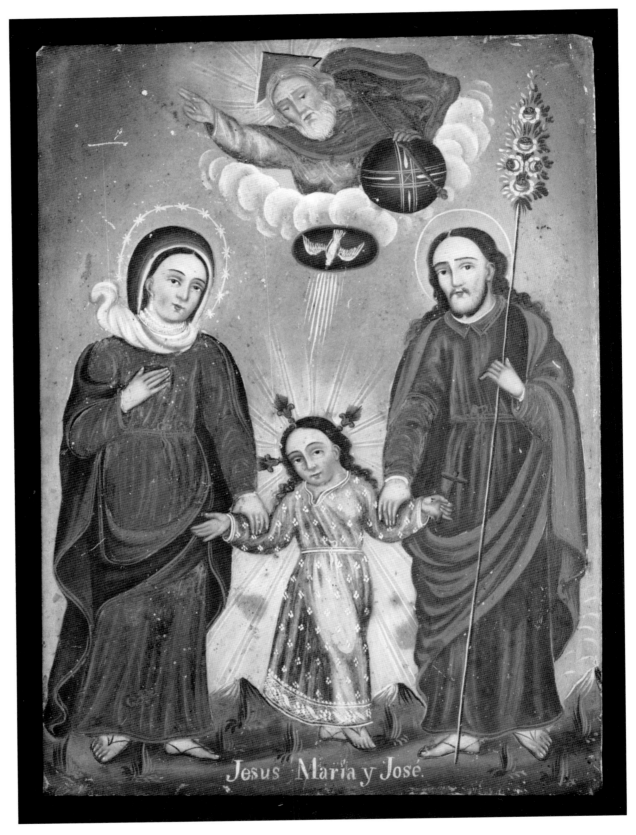

Jesus María y José.

6.

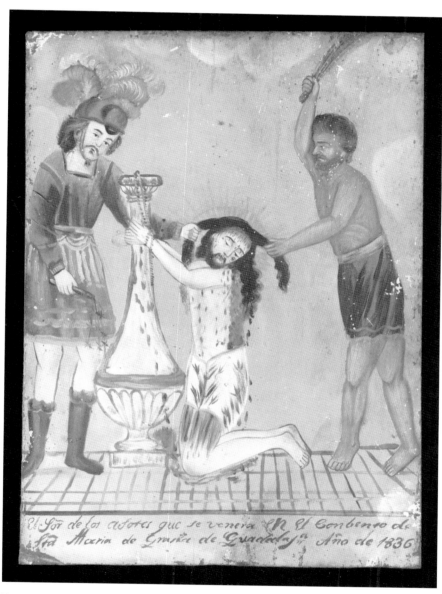

7.

6.

THE HOLY FAMILY

LA SAGRADA FAMILIA

14 x 10 in.
35.5 x 25.4 cm.
Mary and Bob Koenig

Paintings of the Holy Family when accompanied by God the Father and the Holy Ghost take on another dimension. Jesus, Mary, and Joseph form a horizontal, earthly Trinity, and God the Father and the Holy Ghost combine with Christ to create a spiritual, vertical Trinity. In *retablos* this subject is regarded as the symbol of a perfect family.

7.

THE LORD OF THE SCOURGES

EL SEÑOR DE LOS AZOTES

13¾ x 10 in.
34.9 x 25.4 cm.
Mr. and Mrs. Bartell Zachry

This piece has been labelled at the bottom of the painting "The Lord of the Scourges." We are told that it was venerated in the convent of Santa María de Gracia in Guadalajara in the year 1835. The inspiration for this painting most probably came directly from a painting or sculpture in the convent.

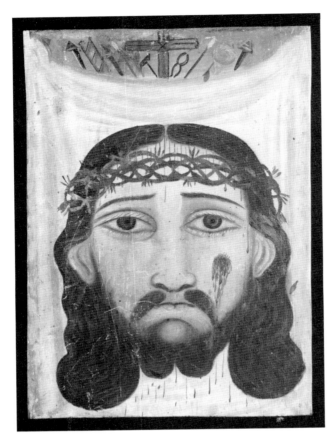

8.

8.
THE DIVINE FACE OR
THE VEIL OF VERONICA

EL DIVINO ROSTRO OR LA VERÓNICA

8¾ x 6⅛ in.
22.22 x 15.6 cm.
Barbara and Justin Kerr

Popular tradition gives the name Veronica (*vera icon*, or true image) to the woman who wiped Christ's face with her veil or handkerchief on his way to Calvary. Miraculously the image of his face and the crown of thorns was transferred to the cloth, which has been preserved as a holy relic in St. Peter's Basilica in Rome.

9.
CHRIST AFTER THE SCOURGING
SEARCHING FOR HIS GARMENTS

EL JESÚS CRISTO, DESPÚES
LA FLAGELACIÓN

5 x 7 in.
12.7 x 17.7 cm.
Private Collection

Jesus, alone in his cell is seen attempting to clothe himself. The instruments of his torture are displayed in the background. This theme was effectively used by Spanish Counter-Reformation and Baroque painters, especially Bartolomé Murillo.

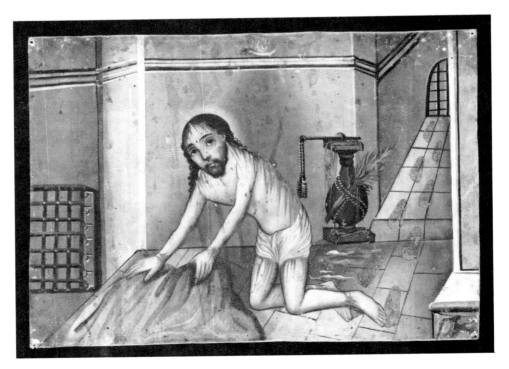

9.

10.
THE LORD OF PUNISHMENT

EL SEÑOR DE LOS PENAS

13¼ x 9½ in.
33.6 x 24.1 cm.
Graciela Cantu

The Lord of Punishment is very similar in content to *El Señor de Trabajos* (No. 15) and has been painted by the same artist. The details clearly show the original source of inspiration, a *paso* figure.

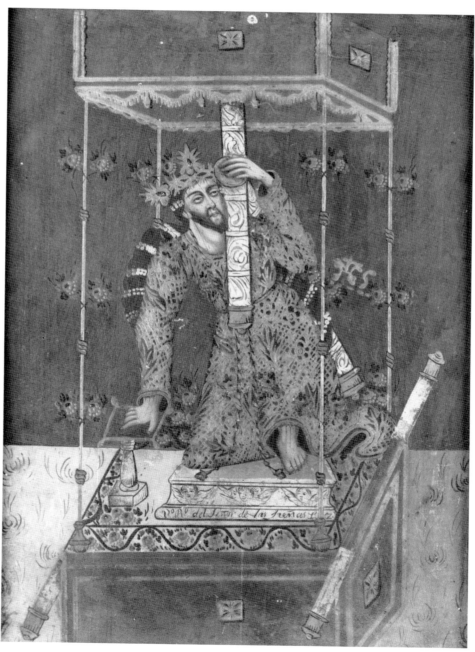

10.

11.

THE CRUCIFIX

EL CRUXIFIJO

14¼ x 10¼ in.
36.1 x 26.0 cm.
Private Collection

In addition to the image of the crucified Christ, urns of flowers and candles are arranged along the bottom as if this were an image found on a side altar. The two hanging objects from either end of the cross arms may be a misinterpretation on the part of this naïve artist of some element from a copied print.

12.

THE LORD OF SAUCITO

EL SEÑOR DE SAUCITO

14 x 10 in.
35.5 x 25.4 cm.
Private Collection

The devotion for the Lord of Saucito, formally known as Our Lord of Burgos, is said to have been established about 1820 in the settlement known as Las Encinillas, or Saucito, just outside the city of San Luis Potosí, Mexico. A local carpenter named Cesáreo de la Cruz and a *santero* named Juan Pablo made a crucifix, which was placed in a humble *ramada*. The enormous popularity of this cult caused ecclesiastical authorities to build a chapel for it on condition that the image be replaced by one done by a professional artist. The present figure was made by the sculptor José María Aguado around 1826, and *retablo* representations of El Señor de Saucito are loyal to this carving.

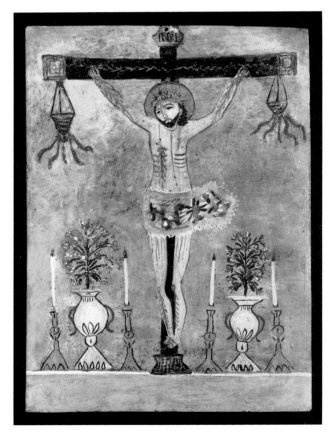

11.

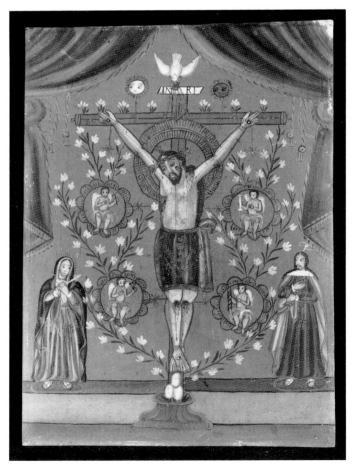

12.

13.

THE CHRIST OF LIGHT

EL SEÑOR DE LUCAR

14 x 10 in.
35.5 x 25.4 cm.
Kurt Stephen

The script at the bottom of the painting informs us that forty days of indulgences will be given to those who venerate this figure, a miraculous image of Our Lord of Lucar in the convent of San Juan de Dios. Christ appears alive, crowned, and dressed as a priest. For some esoteric reason, his right foot has been removed from his shoe and is in the chalice, possibly a Eucharistic symbol.

14. *See Page 8*
THE EUCHARISTIC MAN OF SORROWS

EL HOMBRE EUCARISTICO DE DOLORES O EL VARÓN EUCARISTICO DE DOLORES

14 x 10 in.
35.5 x 25.4 cm.
Kurt Stephen

Although the Eucharistic Man of Sorrows is the iconographically correct title for this non-narrative theme, the label on this piece refers to "the divine providence of Jesus." The figure of Christ with a grapevine coming from his side, his blood feeding the lambs clustered around him, is a Eucharistic symbol.

15. *See Plate III*
THE LORD OF LABORS OF PUEBLA

EL SEÑOR DE LOS TRABAJOS DE PUEBLA

13¼ x 10 in.
33.6 x 25.4 cm.
Private Collection

This image represents Christ on his way to Calvary. From the details on the robe's edge and the decorative cross with clusters of grapes (a popular Christian symbol for the Eucharistic wine and, hence, the blood of Christ) this figure represents the Lord of Hardships, a particular cult image that is revered in Puebla.

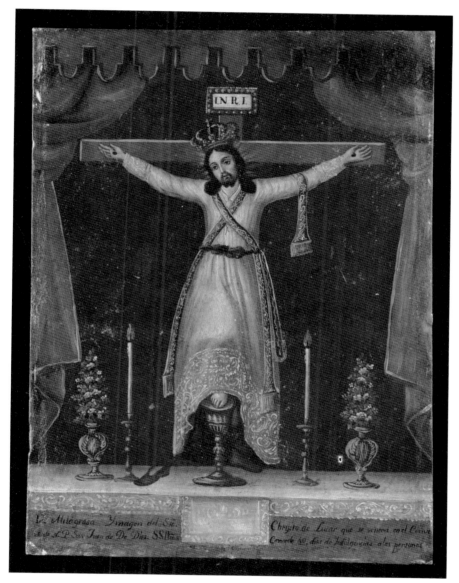

13.

16.
THE LOST CHILD

EL NIÑO PERDIDO

7¼ x 5 in.
18.4 x 12.7 cm.
Martha Egan

The child Jesus becoming separated from his parents is described in Luke, which forms the basis for this cult. This *retablo* comes from a popular figure revered in Cuencemé de Ceniceros in Durango, Mexico, complete with the ruffled cap and gold coins that had been pinned to his gown. The lost child Jesus is one of the seven sorrows of Mary.

17. *See Plate IV*
THE CHILD OF ATOCHA

EL NIÑO DE ATOCHA

14 x 10 in.
35.5 x 25.4 cm.
Private Collection

18.
THE CHILD OF ATOCHA

EL NIÑO DE ATOCHA

10 x 7 in.
25.4 x 17.7 cm.
Private Collection

16.

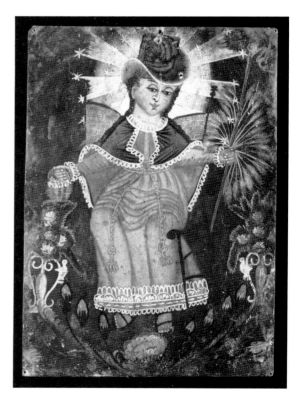

18.

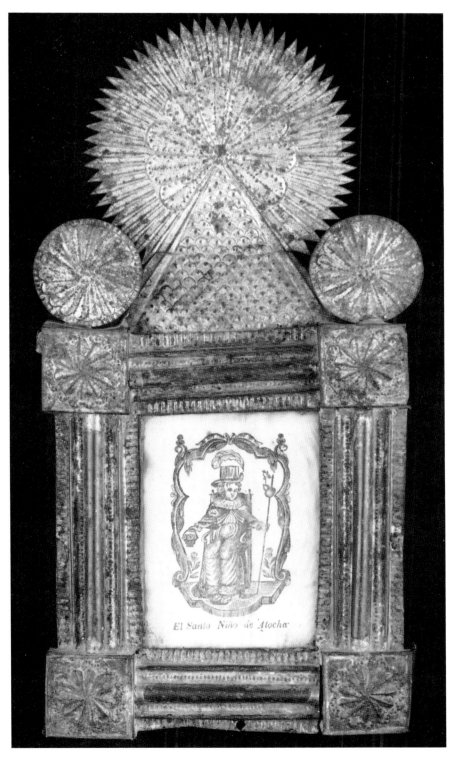

19.

19.
EL NIÑO DE ATOCHA

ENGRAVING ON PAPER

5 x 3 in.
12.7 x 7.6 cm.
Tonia and Bob Clark

The legend of a child pilgrim (actually the Christ child undetected) who assists the prisoners of the Moors is a Mexican tradition that probably developed around the end of the eighteenth century in the area of Fresnillo, in Zacatecas. His sanctuary, which is full of *ex-votos* thanking him for miracles of all types, is located in Plateros, near Fresnillo. One of the most popular themes in *retablo* art, El Niño de Atocha is considered effective in gaining the release of prisoners.

20.
THE SOUL OF MARY

LA ALMA DE MARÍA O LA ANUNCIACIÓN

10 x 7 in.
25.4 x 17.7 cm.
Mr. and Mrs. Graham Gray

The Soul of Mary, or the Annunciate, describes the Virgin at the moment of the announcement by the angel Gabriel. The lilies, symbolizing Mary's purity, and the dove, the symbol for the Holy Spirit, are always present. In *retablo* art she is usually crowned with roses, another symbol of her purity, and there may be stars surrounding her head.

21.
THE PIETA

LA PIÉTA

14 x 10¼ in.
35.5 x 26.0 cm.
Nancy Hamilton

This *retablo* depicts the scene immediately after Christ's body has been removed from the cross, although this is not described in the gospels. In *retablo* art Mary often has a dagger in her heart, alluding to her role as Mater Dolorosa. The tradition of portraying Christ as smaller than the Virgin is a medieval device borrowed by Renaissance artists and used frequently thereafter.

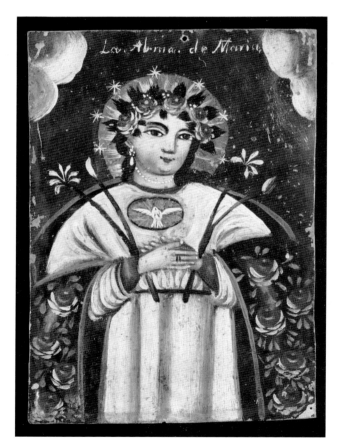

20.

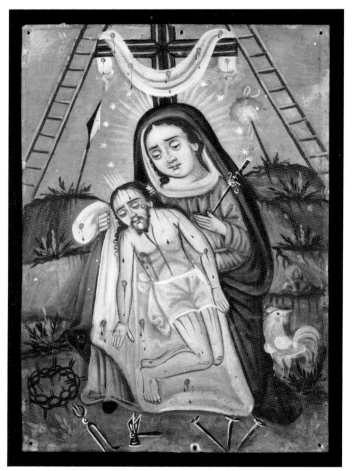

21.

22.
OUR LADY, REFUGE OF SINNERS

NUESTRA SEÑORA, REFUGIO
DE LOS PECADORES

20¼ x 14¼ in.
51.4 x 36.1 cm.
Ellen Price McClure

23. *See Plate V*
OUR LADY, REFUGE OF SINNERS

NUESTRA SEÑORA, REFUGIO
DE LOS PECADORES

14¼ x 10 in.
36.1 x 25.4 cm.
Private Collection

24.
OUR LADY, REFUGE OF SINNERS

NUESTRA SEÑORA, REFUGIO
DE LOS PECADORES

10 x 7 in.
25.4 x 17.7 cm.
Loaned anonymously in memory of
Celestine Chinn, O.F.M.

22.

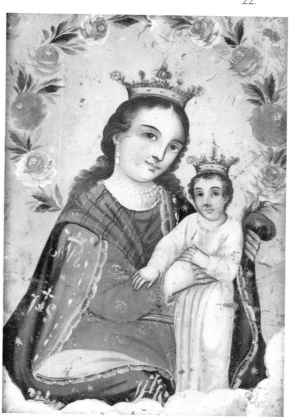

24.

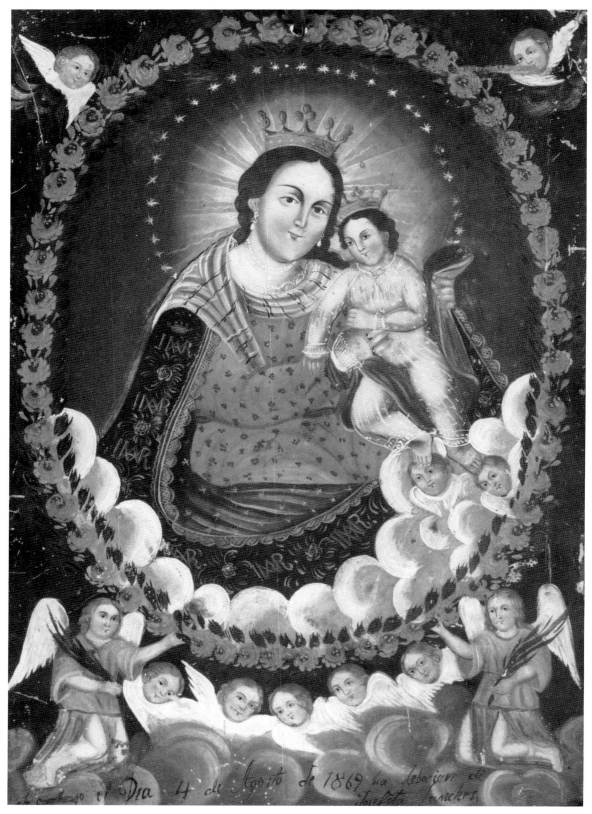

25.

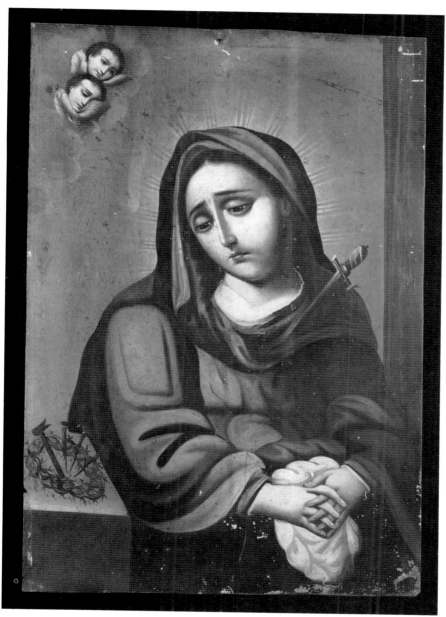

25.

OUR LADY, REFUGE OF SINNERS

NUESTRA SEÑORA, REFUGIO
DE LOS PECADORES

16 x 11¼ in.
40.6 x 28.5 cm.
Nancy Hamilton

The original painting of Our Lady, Refuge of Sinners was brought to Mexico from Italy in 1719 by a Jesuit missionary and placed in the Cathedral of Zacatecas, where she became the town's patron. The popularity of this image created an enormous demand for representations, and different artists created interesting variations on the theme, four of which are presented here. This image was the most popular representation in *retablo* art.

26.

OUR LADY OF SORROWS

LA MADRE DOLOROSA

13 x 9 in.
33.0 x 22.8 cm.
Richard Worthen Galleries

The sorrowful mother shows Mary after the Crucifixion, contemplating the objects of her son's torture and death. A dagger pierces her heart, a literal rendering of the prophecy of Simeon: "This child is destined to be a sign which men reject: and you too shall be pierced to the heart." This theme is included in the devotion of a Holy Death, and has been elaborated on to include the seven sorrows.

26.

32.
OUR LADY OF THE ROSARY OF TALPA

NUESTRA SEÑORA DEL ROSARIO DE TALPA

14 x 10 in.
35.5 x 25.4 cm.
Tiqua Gallery

Our Lady of the Rosary is a devotion popularized after the decisive Spanish victory at Lepanto in 1571 over the Moors (it is said her image was used as inspiration during the battle). The Dominican Order was largely responsible for its proliferation. This image is from Talpa, an important pilgrimage center in Jalisco.

33.
OUR LADY OF MOUNT CARMEL

NUESTRA SEÑORA DEL CARMEN

6½ x 4¼ in.
16.5 x 10.7 cm.
Mr. and Mrs. Francis E. Tolland

Mary is seen dressed in the robes of the Carmelite order. The brown robe, the scapulars she and Christ hold, and the shield of the Carmelite order distinguish her from other Virgins, including another similar figure, N. S. de Merced (Our Lady of Mercy), patron of the Mercedarian Order.

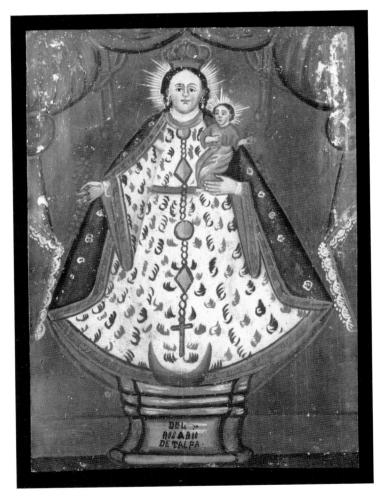

32.

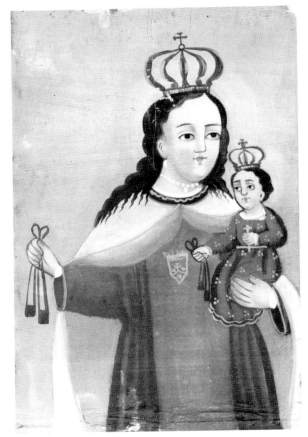

33.

34. *See Cover*
Our Lady of San Juan de los Lagos

Nuestra Señora de San Juan
de los Lagos

14 x 10 in.
35.5 x 25.4 cm.
Private Collection

This image of Mary is said to have been revered in the parochial church city of San Juan de los Lagos, Jalisco since the early seventeenth century. This very popular figure, less than a foot high, is formed from *pasta de Michoacan* (or *caña de maíz*), a material made from corn pith and other plant juices that can be molded and later painted. She is distinguished in *retablo* art by her crown (sometimes held between two angels), a bell-shaped, embroidered white dress with a distinctive white ruffled collar and blue mantle, and candles on either side. Because her garments have been replaced as acts of piety in the past century, currently they do not include the mantle or collar.

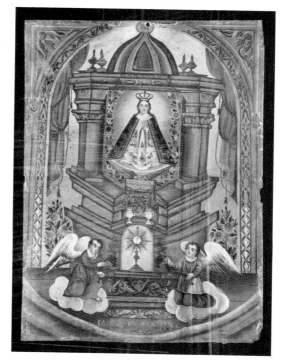

34.

35.
Our Lady of the Holy Cave

Nuestra Señora de la Cueva Santa

20 x 14 in.
50.8 x 35.5 cm.
Tiqua Gallery

From a cult of Spanish origin, this figure is easily recognized. The Virgin is always shown bust size, wrapped in a white mantle that is secured in the front, while surrounding her is some indication of a cave-like structure. Of minor importance in *retablo* art, many examples of this figure have pleasingly simple and abstract qualities.

35.

36. *See Plate VIII*
OUR LADY OF OCOTLAN

NUESTRA SEÑORA DE OCOTLÁN

13¼ x 9½ in.
34 x 24 cm.
Graciela Cantu

In the year 1541 the territory of Tlaxcala was stricken by smallpox, with terrible losses among the native people. An Indian, Juan Diego, while seeking a healing water for stricken relatives, encountered a beautiful woman who told him that she would give him water that would cure any who drank it. She instructed him to tell the Franciscan friars where they could find her image and that she wanted it placed in the chapel of San Lorenzo. Following his instructions they found her image inside the trunk of an *ocote* (a species of pine). Ocotlán means the place of the *ocote*. She is the patroness of Tlaxcala.

37.
THE LONESOME SOUL

LA ÁNIMA SOLA

8½ x 6¼ in.
21.5 x 15.8 cm.
Tonia and Bob Clark

The alone or lonely soul refers to one of the images important to the cult of the Souls in Purgatory. According to popular custom, artists would place the name of the deceased on some of the figures so that relatives would pray for the repose of his soul.

38.
CROSS OF SOULS OR ARMA CHRISTI

CRUZ DE ÁNIMAS OR ARMA CHRISTI

13 x 9½ in.
33.0 x 24.1 cm.
Private Collection

The Cross of Souls combines the *Arma Christi*, a Franciscan devotion that depicts Jesus crucified and surrounded by the Instruments of the Passion, with figures of the Souls in Purgatory. This particular *retablo* appears to be based on three-dimensional representations of this theme.

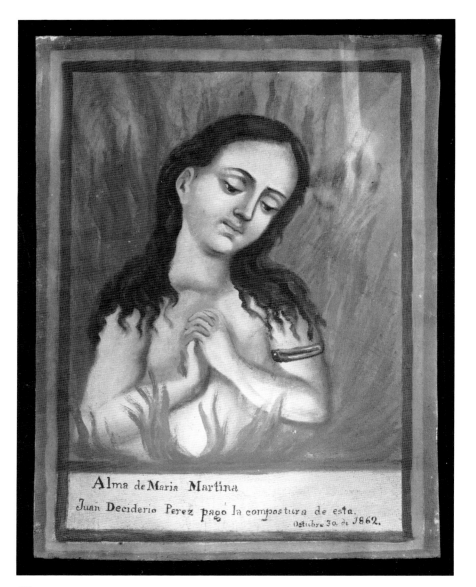

37.

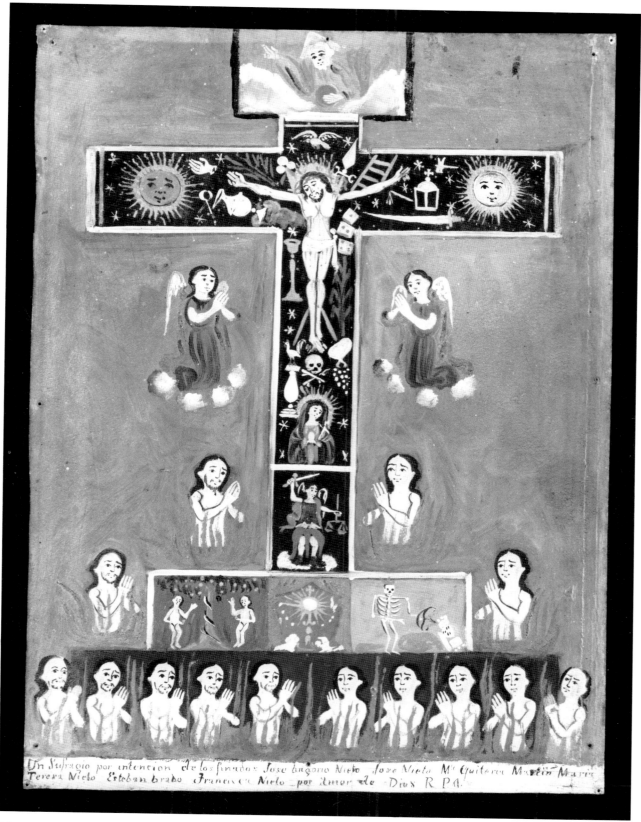

Un Sufragio por intencion de los finados Jose Antonio Nieto Jose Nieto Mª Guitarra Martin Maria
Teresa Nieto Esteban brabo Francisca Nieto por Amor de Dios R P A.

38.

39.

THE SEVEN ARCHANGELS

LOS SIETE PRINCIPES

Hand-tinted engraving on paper

8 x 11¼ in.
20.3 x 28.5 cm.
Bill Adams

This hand-tinted engraving, printed in San Luis Potosí in 1841, informs the reader that a number of bishops throughout Mexico will grant 160 days of indulgences to individuals who will say an Our Father and Hail Mary or a prayer dedicated to the seven princes, or seven archangels. A set of seven *retablos* were painted using a print such as this for a guide; *San Gabriel* is one of them.

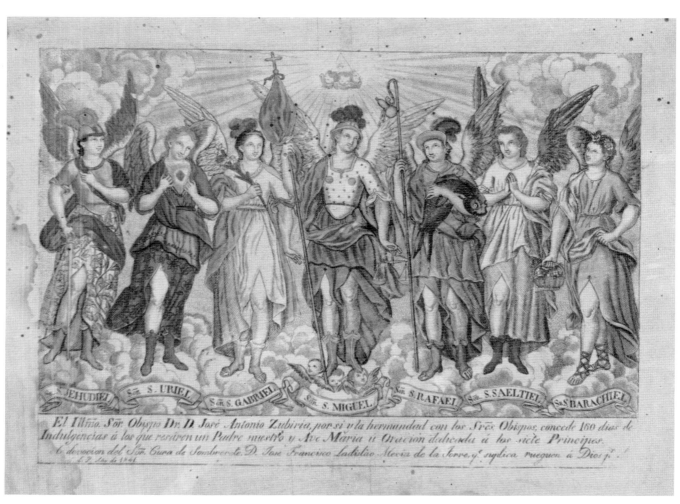

39.

40.
SAINT ACACIUS THE MARTYR

SAN ACACIO, MARTÍR

12¾ x 9¾ in.
32.3 x 24.7 cm.
Mary and Bob Koenig

The legend of Acacius relates that he was a Roman soldier during the second century who converted to Christianity and in turn converted other soldiers who were sent to return him to military duty. All of them were finally captured and sentenced to death, and it is said that at the time of his crucifixion God gave him the power of bestowing health and earthly goods to those who would remember him. One of the Fourteen Holy Helpers, a group of saints with special intercessory powers, he was sought to cure headaches. Popular Mexican tradition includes contemporary armaments and sometimes clothing in his representation.

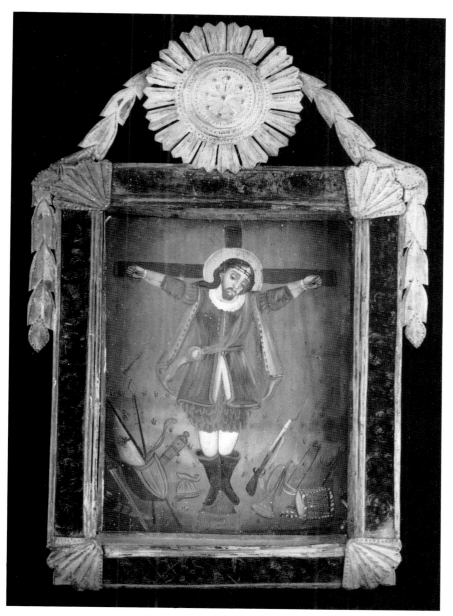

40.

41. *See Plate IX*
SAINT ANGELUS THE MARTYR

SAN ANGELO, MARTÍR

14 x 10 in.
35.5 x 25.4 cm.
Private Collection

Killed by heretics in 1220, Angelus was an early Carmelite who is shown here with the instrument of his assassination, an ax in his head, as well as with traditional symbols, including a palm leaf ringed with three crowns, signifying chastity, eloquence, and martyrdom.

42.
SAINT ANNE

SANTA ANA

14 x 10 in.
35.5 x 25.4 cm.
Nancy Hamilton

The thirteenth-century Golden Legend provides most of the story of the mother of Mary, of whom all accounts are apocryphal. The legend says that after twenty years of a barren marriage, an angel announced to Saint Anne and her husband, Joachim, that she would conceive a child who would be the mother of Jesus, and she conceived immediately. She is the patron of childless women and also of mothers, because of the pious manner in which she raised her daughter.

43.
SAINT ANTHONY OF PADUA

SAN ANTONIO DE PADUA

12¾ x 9 in.
32.3 x 22.8 cm.
Margaret A. Clark

St. Anthony is a native of Lisbon, Portugal, though his surname derives from Padua, Italy, where he lived last and where his relics are venerated. He joined the regular canons of St. Augustine at the age of fifteen and later was admitted to the Franciscan order. A compelling preacher with a magnetic personality, the mere sight of him is said to have "brought sinners to their knees," and many were converted and brought to confession at his sermons. Popular tales of his many miracles have made him the patron saint of lost articles, horses, unmarried women seeking husbands, and the poor.

42.

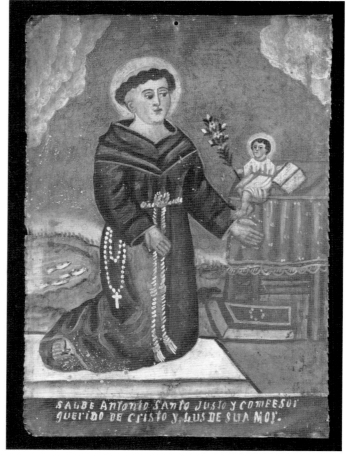

43.

44. *See Plate X*
SAINT BENEDICT OF PALERMO

SAN BENITO DE PALERMO

3¼ x 2¼ in. (image size)
8.26 x 5.72 cm.
The Mexican Museum, San Francisco

A free son of Christianized African slaves, from a young age his piety earned him the nickname "The Holy Black." St. Benito is distinguishable from St. Martin de Porres by his Franciscan robe. The lily, crucifix, scourge, and flaming heart are usually present in *retablo* images of him, symbols of his purity, piety, and religious fervor. He was considered the patron of black slaves in Latin America.

45.
SAINT BONIFACE THE MARTYR

SAN BONIFACIO, MARTÍR

8½ x 6 in.
21.5 x 15.2 cm.
Doug and Rhonda Forsha

Converted to Christianity in the fourth century along with a female companion, Aglae, Boniface was beheaded at Tarsus, where he had gone from Rome at Aglae's request to recover the bodies of certain martyrs. His own body was returned to her, and she placed it in an oratory. Later his relics were enshrined in a church dedicated to him. He usually is dressed as a soldier, and the symbols of his faith and martyrdom, the cross, palm, and weapon, are usually included in his representations.

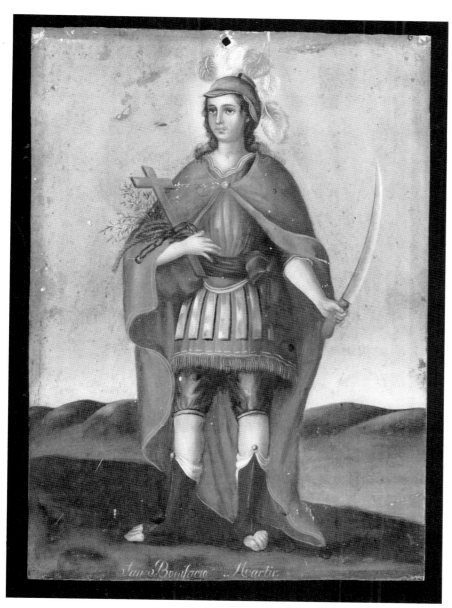

45.

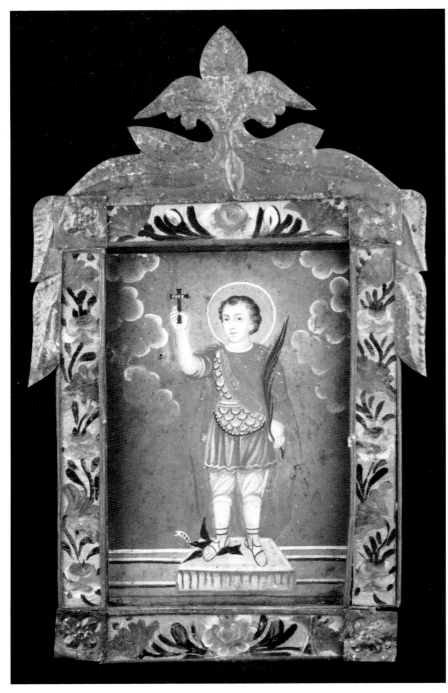

47.

46. *See Plate XI*
SAINT CAMILLUS OF LELIS

SAN CAMILLO DE LELIS

7 x 4¾ in.
17.7 x 12.0 cm.
Barbara and Justin Kerr

Camillus de Lelis, founder of the Ministers of the Sick, was born in 1550 at Bocchianico in the Abruzzi. A soldier who had fought the Turks, he renounced his addiction to gambling, was converted, and entered a religious order. Because he believed that spiritual assistance to the sick and dying was crucial to their physical well-being and founded an order with this mission, he is important in the devotion of a Happy (or Holy) Death. He is recognizable by his black habit and red cross. Popularly he is the patron saint of gamblers.

47.
SAINT EXPEDITUS

SAN EXPIDITO

10 x 6½ in.
2.54 x 16.5 cm.
Private Collection

Popular legends say the devotion to Expeditus originated when a carton of holy relics arrived for a community of nuns in seventeenth-century Paris with the label *spedito*. Mistaking shipping instructions for the name of a martyr, the nuns set about propagating his cult. The play on words has made him the patron of dispatchers and the protector against procrastination.

48.
SAINT FRANCIS OF PAUL

SAN FRANCISCO DE PAOLA

17¼ x 13¼ in.
43.8 x 33.6 cm.
Mr. and Mrs. Joseph P. Peters

Founder of the Minim Friars, St. Francis of Paola chose charity as his motto. The word *caridad* is one of the most important attributes to identify this saint, as well as the flames that may either surround the word or are seen on his chest. A lamb emerging from a burning oven is also a common feature. Because he travelled across the sea using his cloak as a boat and sail, he may be considered the patron of sailors.

49. *See Page 12*
SAINT GABRIEL THE ARCHANGEL

SAN GABRIEL, ARCANGEL

14 x 9½ in.
35.5 x 24.1 cm.
Bill Adams

Copied from a print (No. 39) Gabriel is shown holding his principal attribute, a white lily—the symbol of purity. He is considered to be the angel of the Annunciation and the Nativity. In recent years he has been named the patron of workers in the telecommunications industry, postmen, and diplomats.

50.
SAINT HEDWIG

SANTA EDUVIGES

14 x 10 in.
35.5 x 25.4 cm.
Kurt Stephen

Hedwig, the ducal daughter, married Duke Henry of Poland in the thirteenth century and devoted her life to religious perfection. She was known for administering to the poor, afflicted, and imprisoned. Her crown indicates her lineage and the abbess' staff refers to the Cistercian abbey she founded and funded at Trebnitz. She is a patron of the poor and the infirm.

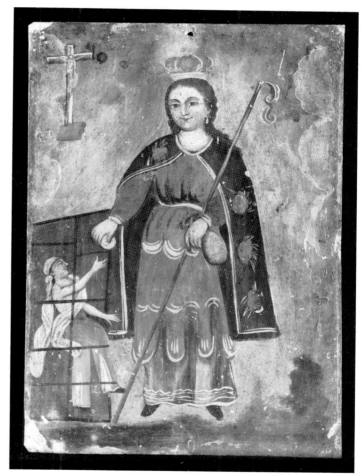

50.

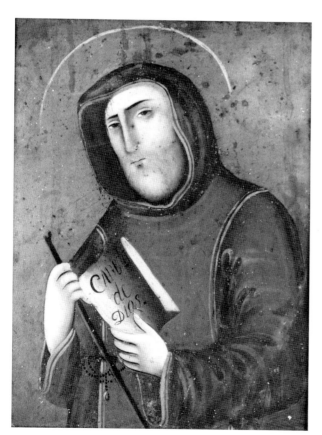

48.

51.
SAINT HELEN

SANTA ELENA

14 x 9¾ in.
35.5 x 24.7 cm.
Nancy Hamilton

The mother of the emperor Constantine, Helen was converted to Christianity and spent her later years constructing churches and searching in Jerusalem for the cross on which Christ was crucified. She is almost always shown dressed as a queen with some type of turban to suggest her eastern birthplace. The crown of thorns and three nails are usually included in her representations as well.

52. *See Plate XII*
SAINT ISIDOR THE LABORER

SAN ISIDRO, LABRADOR

14 x 10¼ in.
35.5 x 26.0 cm.
Nancy Hamilton

Isidro de la Cabeza was a pious Spanish laborer. He is traditionally the patron for farmers, responsible for the harvest and for good weather. There are a number of charming legends concerning him, one of which says that Isidore was so busy working he could not get to church, so God sent an angel to help him resume his devotions.

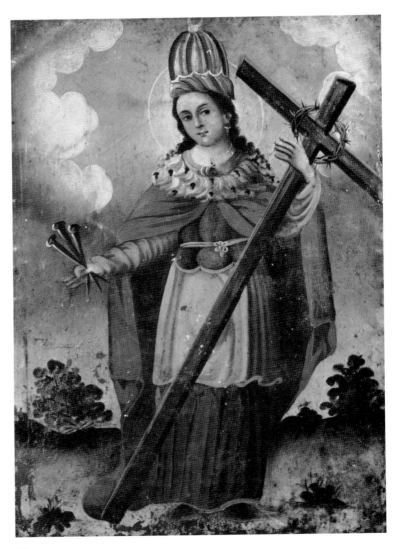

51.

53.

SAINT JAMES THE ELDER, APOSTLE

SANTIAGO MATAMOROS

7 x 5 in.
17.9 x 12.7 cm.
Private Collection

The apostle, brother of St. John the Evangelist and son of Zebedee, James was called the Greater to distinguish him from another apostle of the same name. According to legend he preached throughout Spain, where his body was returned for burial after his martyrdom. In the ninth century, his burial place was revealed miraculously as Compostela, which became an enormously important pilgrimage site during the Middle Ages. He is the patron saint of Spain, and the patron for horses and horsemen.

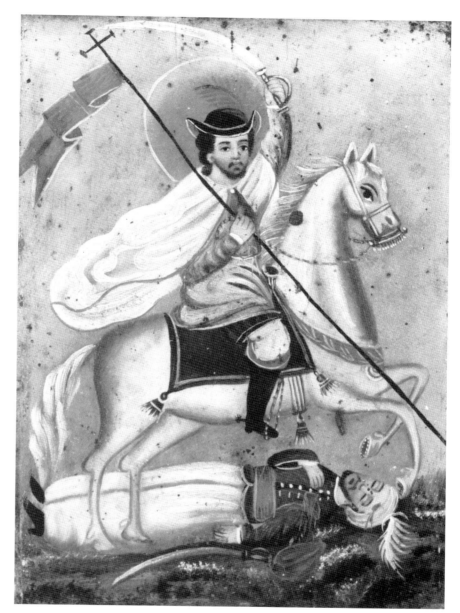

53.

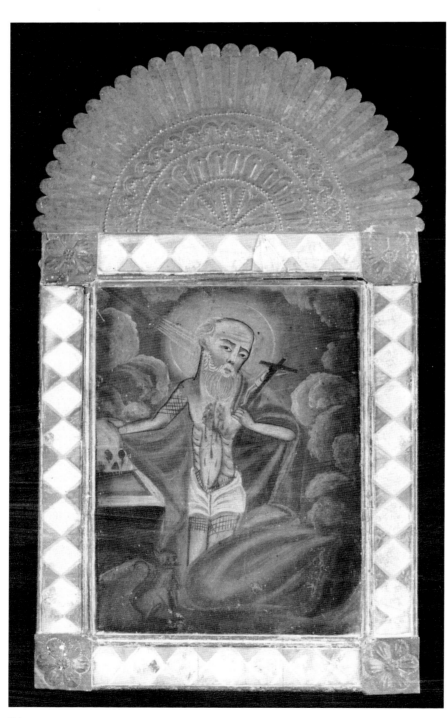

54.

54.

SAINT JEROME

SAN JERÓNIMO

10 x 7 in.
25.4 x 17.7 cm.
Loretta Russell Hoffmann

Jerome is the doctor of the church, reviser of the gospels and psalms, and the translator from Hebrew into Latin of most of the Old Testament (the Vulgate). He is shown in *retablo* art as a hermit contemplating the symbols of his penitential life. His principal attributes are the hat and robe of a cardinal (a role he never served, but the early priests of Rome served functions that later were given to cardinals) and a lion. Although there are legends concerning the animal, Jerome's representations have probably acquired it through confusion with another saint with a similar name.

55.

SAINT JOHN THE BAPTIST

SAN JUAN BAUTISTA

9 x 6¼ in.
22.8 x 15.8 cm.
Janis and Robert Keller

Christ's first cousin, John led a hermit's life. He is shown dressed in "his raiment of camel's hair, and a leathern girdle about his loins" (Matt. 3:4). He is depicted either baptizing Christ or holding a staff, a scroll enscribed *Ecce Agnus Dei* ("Behold the Lamb of God," John 1:36), and a lamb on a book referring to the Baptism and his prophecy. He is the patron of baptisms and, in Spain, the patron of sword cutlers.

56.

SAINT JOHN NEPOMECEN

SAN JUAN NEPUMOCENO

9 x 6½ in.
22.8 x 16.5 cm.
Private Collection

John Nepomecen is regarded as a patron of confessors, those wishing to make a good confession, secret-keepers, and bridges. Tradition attributes this Bohemian saint's martyrdom to his having been confessor to the wife of Wenceslaus IV and his refusal to reveal her confession to the king. He was, in fact, brutally tortured by this king and bound, gagged, and thrown into the river Moldau from a bridge. It is said that seven stars hovered over the water on the night of his murder. The stars usually are included in his representations, as well as the martyr's palm and some gesture of secrecy, keys, a tongue, or as here, an angel with a finger on his lips. He also is said to protect against infected water.

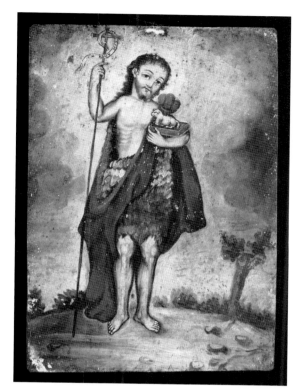

55.

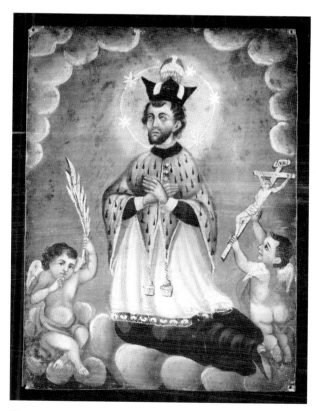

56.

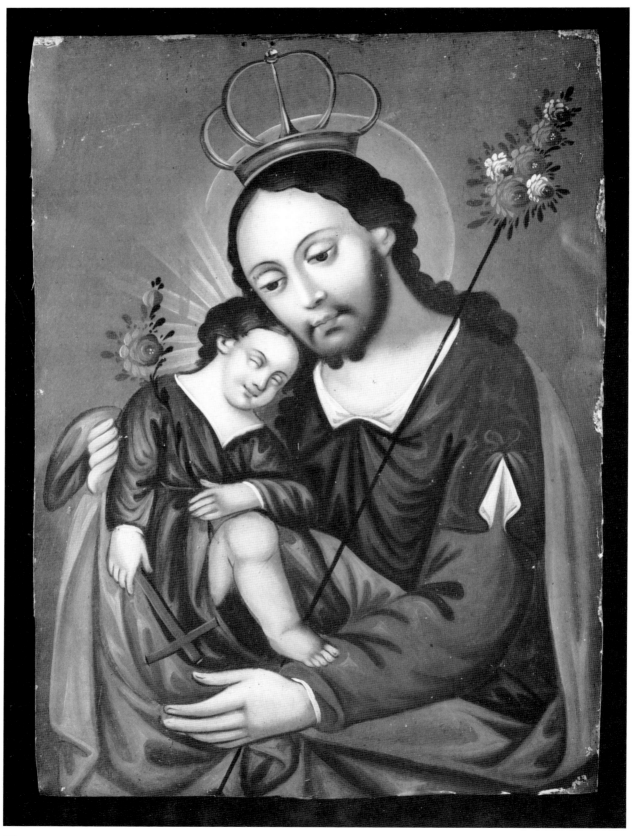

57.

57.
SAINT JOSEPH

SAN JOSÉ

13½ x 9¾ in.
34.3 x 24.7 cm.
Tiqua Gallery

58.
SAINT JOSEPH

SAN JOSÉ

20 x 13½ in.
50.8 x 34.3 cm.
Ray Pearson

59. *See Plate XIII*
SAINT JOSEPH

SAN JOSÉ

12½ x 9½ in.
31.7 x 24.1 cm.
Joe and Rae Neumen

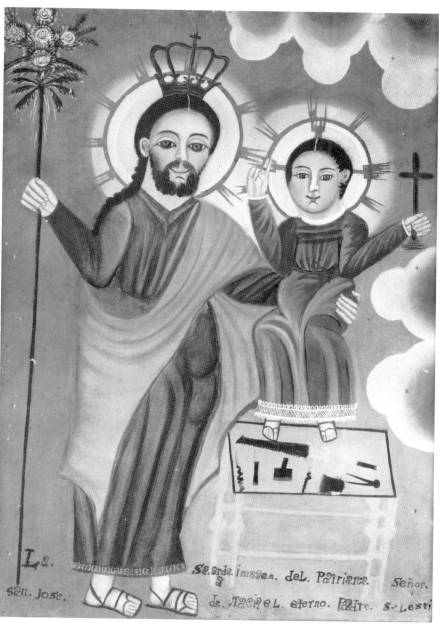

58.

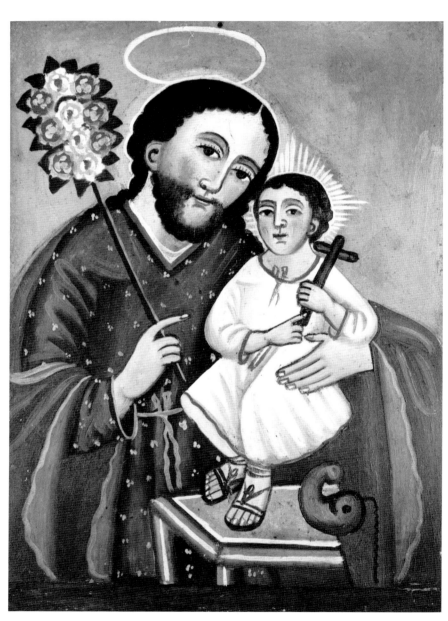

60.

60.
<small>SAINT JOSEPH</small>

<small>SAN JOSÉ</small>

14 x 10 in.
35.5 x 25.4 cm.
Private Collection

Legend says St. Joseph was chosen to be the husband of Mary because of all the other suitors his staff bloomed. This flowering staff is his attribute. He is usually shown dressed in green and yellow, the colors of fertility, hope, and regeneration and marriage, faith, and fruitfulness. He may appear crowned but he is always depicted with the child Jesus. He is the patron of carpenters and a model for the ideal husband and father.

61.
SAINT LEONARD

SAN LEONARDO

7 x 5 in.
17.7 x 12.7 cm.
Carroll Collection

According to the legend, Leonard's prayers assisted King Clovis' wife in a safe delivery, thus he is the patron saint of childbirth. The convent he founded in southern France was dedicated to the rescue and conversion of Turkish prisoners; another legend says King Clovis promised freedom to every captive Leonard could visit. Fact and fiction combine to make him also the patron of captives. He is recognized by the dalmatic he wears and the prisoners or women seen praying at his feet.

62.
SAINT LIBERATA OR WILGEFORTIS

SANTA LIBRATA

14 x 10 in.
35.5 x 25.4 cm.
Nancy Hamilton

Liberata (or Wilgefortis) was the daughter of a prince. She prayed to God for the loss of her beauty in order to avoid marriage and consequently was able to grow a beard. Outraged and humiliated, her father ordered her to be crucified. She is one of the Fourteen Holy Helpers, she protects against headaches, and she is the patroness of laundresses.

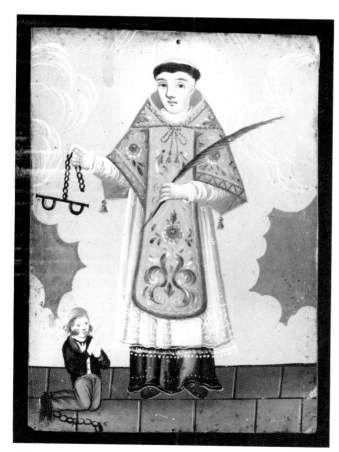

61.

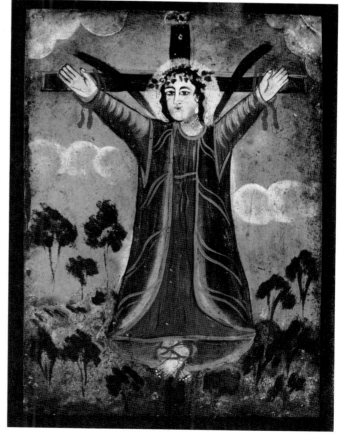

62.

63.

SAINT LUTGARDE

SANTA LUDGARDA

14 x 9½ in.
35.5 x 24.5 cm.
Private Collection

Consecrated to God at the age of twelve,
Lutgarde spent most of her life as a Cister-
cian nun. Famous for her holiness and her
miracles, she is always shown at the side
of the crucifix where the figure of Christ
embraces her. A tabernacle is included
here to indicate her continual prayers.

64.

SAINT MARTIN OF TOURS

SAN MARTÍN DE TOURS

14¼ x 10 in.
36.1 x 25.4 cm.
Ellen Price McClure

Martin was a fourth-century soldier who,
while not a Christian, lived more like a
monk. While stationed in Amiens an inci-
dent was said to have changed his life.
One bitterly cold day he met an almost
naked beggar. Martin cut his cloak in two,
giving part of it to the man. That night
Martin had a dream in which Jesus Christ
appeared before him wrapped in his cloak.
He converted to Christianity and later be-
came the bishop of Tours. He is the patron
for horses, soldiers, and beggars.

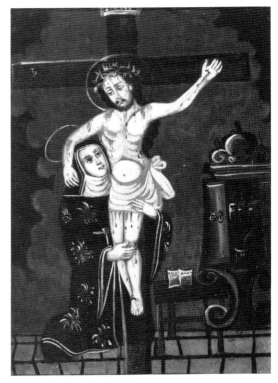

63.

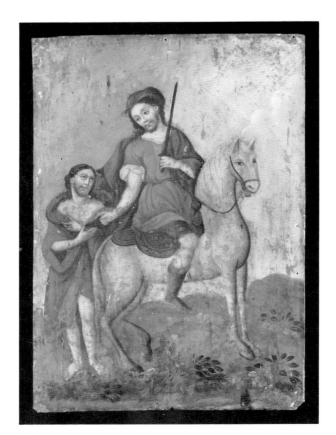

64.

65. *See Frontispiece*
SAINT MICHAEL THE ARCHANGEL

SAN MIGUEL, ARCANGEL

10 x 7 in.
25.4 x 17.7 cm.
Private Collection

The general of heaven's angels, Michael is the conqueror of Lucifer, protector of the Church, and symbol of the Church Militant. He is invoked at the hour of death and to protect against demons. Recently security forces, paratroopers, and radiologists have come under his protection.

66.
SAINT NICOLAS OF BARI

SAN NICOLÁS DE BARI

14 x 10 in.
35.5 x 25.4 cm.
Private Collection

Born wealthy, Nicolas decided to give his fortune away to the poor. Upon learning that a man had three unmarried daughters and no dowries, he secretly supplied the family with the money needed. It is believed that the three purses represented in images of him became mistaken for three children, giving rise to the legend of three children killed by an innkeeper and pickeled in a brine-tub. Based on these legends and the manner in which his body was brought from Myra to Bari, he is the patron of unmarried women, brides, bakers, children, barrel makers, and sailors.

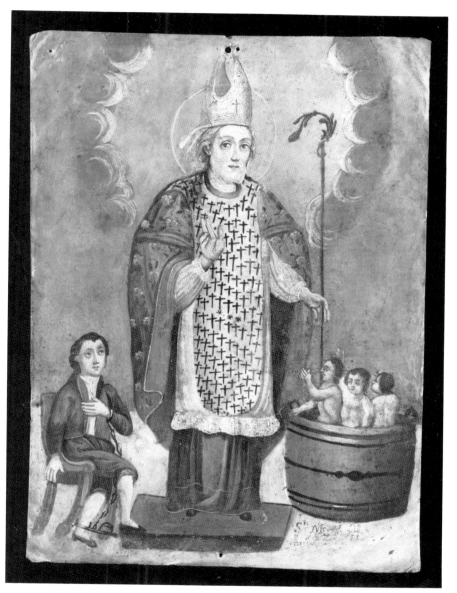

66.

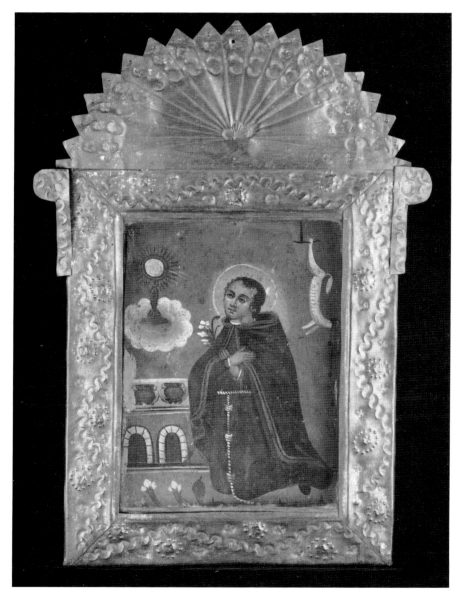

67.

67.
SAINT PASCHAL BAYLON

SAN PASCUAL BAILÓN

10 x 7 in.
25.4 x 17.7 cm.
Ray and Sarah Balinskas

A shepherd from the age of seven to twenty-four, Paschal Baylon was admitted to the order of barefoot Friars Minor. Especially devoted to the Eucharist, he would spend hours in contemplation of it. Legend says that one of his tasks in the convent was to cook, and the meals were prepared by angels so he could continue his meditation in the kitchen. He is the patron of shepherds, the kitchen, and the Eucharistic guilds, and he is said to guard against a sad spirit.

68.
SAINT RAPHAEL THE ARCHANGEL

SAN RAFAEL, ARCANGEL

6½ x 4½ in.
16.5 x 11.4 cm.
Joe and Rae Neumen

The archangel Raphael is seen almost always in *retablos* dressed in a pilgrim's cape, holding a staff and gourd and carrying a fish, after the tale of Tobias in the Apocrypha. Tobias never is shown in Mexican *retablo* painting, but because of the tale Raphael has become the protector of travelers and youth. He also is known to protect against illness of the eyes.

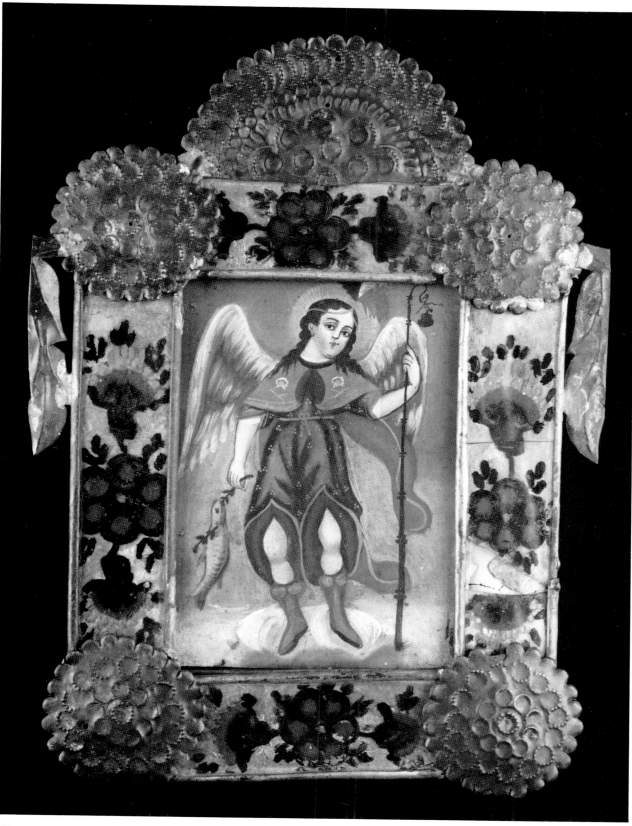

68.

69.
SAINT RAYMUND NONATUS AND
SAINT PHILIP OF JESUS

SAN RAMÓN NONATO AND
SAN FELIPE DE JESÚS

14 x 10 in.
35.5 x 25.4 cm.
Kurt Stephen

This *retablo* contains a double image, an uncommon manner of presenting figures, probably painted by special request and possibly because of the owner's devotion to these two particular figures. Raymund was called *non natus*, "not born," because his mother died in labor and he was taken from her body. He joined the order of Mercedarians, which recently had been founded to assist the ransoming of prisoners. In his office as a ransomer in Algiers he became a captive in order to free another, and, to keep him from preaching and trying to convert the Muslims, the governor had a padlock placed through his lips. He usually is shown with a palm with the three crowns of chastity, eloquence, and martyrdom and with a monstrance, indicating that he received communion from an angel at his hour of death. He is considered the patron of secret-keeping, of midwives, childbirth, pregnant women, and of the falsely accused.

Philip of Jesus, the proto-martyr of Japan, is considered Mexico's first martyr. He died near Nagasaki in 1597. As a young man undecided about becoming a Franciscan, he sailed from Mexico to Japan with the order. While there he experienced a religious conversion, was ordained, and later killed during a religious persecution. He is always shown crucified with two lances thrust through his body. He is the patron of young people.

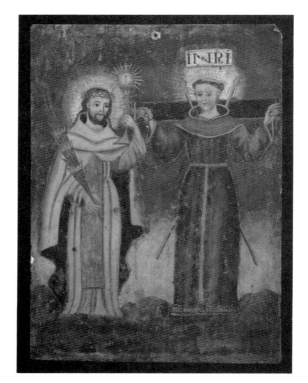

69.

70.
SAINT REMIGIUS, BISHOP

SAN REMIGIO, OBISPO

14 x 10 in.
35.5 x 25.4 cm.
Kurt Stephen

Remegius (Remy), apostle of the Franks, was consecrated archbishop of Rheims at the age of only twenty-two and served in that capacity for over seventy years. He was considered the most erudite and eloquent prelate of the age and "one of the greatest glories of the French Church."

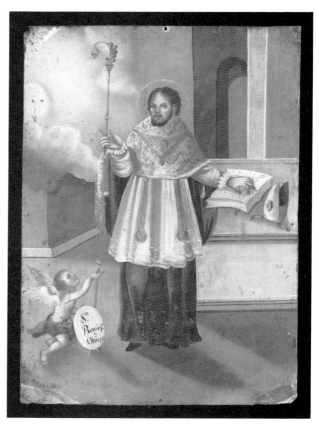

70.

71. *See Plate XIV*
SAINT RITA OF CASCIA

SANTA RITA DE CASCIA

6¾ x 4½ in.
17.1 x 11.4 cm.
Pamela Pettis Mitchell

Rita was admitted to the Augustinian convent after the death of her husband. While meditating before an image of the Crucifixion, a thorn became embedded in her forehead. The thorn is her principal attribute, but she also is shown with a crucifix, skull, and scourge, symbols of her penitence and contemplation. There may be two young men included in her representations, her sons who she prayed would die rather that avenge their father's death. She is invoked for impossible causes and for childhood sicknesses.

72.
SAINT TERESA OF AVILA

SANTA TERESA DE JESÚS OR DE ÁVILA

14 x 9½ in.
35.5 x 24.1 cm.
Loretta Russell Hoffmann

Teresa is considered one of the most important authors of mystic literature of the sixteenth century. A member of the Carmelite order, she founded a number of Spanish convents with reformed, austere programs. Her attribute is a biretta indicating the title of doctor bestowed upon her by the University of Salamanca.

73.
SAINT VINCENT FERRER

SAN VICENTE DE FERRER

14 x 10 in.
35.5 x 25.4 cm.
Kurt Stephen

St. Vincent Ferrer received the Dominican habit in 1367. A powerful speaker, his eloquence converted Jews and roused careless Catholics to penitence. Conversions and miracles followed him everywhere, causing great consternation among his superiors. One of the most popular miracles concerned a laborer who fell from a building, whom Vincent was said to have suspended in midair until permission was received from the bishop to save him. He thus became the patron saint of brick-layers. He is identifiable by his habit, the inscription *Timete Dominum et date illi honorem quia venit hora jucicii eius*, and his wings. Vincent believed he was the angel of judgment foretold by St. John, chosen by God to announce the imminent destruction of the world.

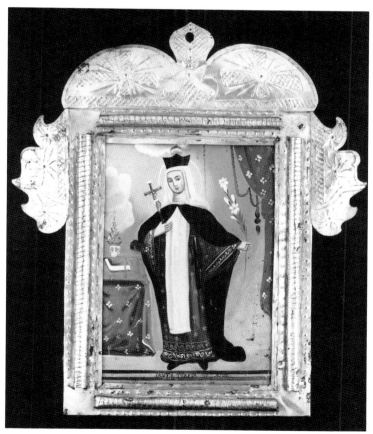

72.

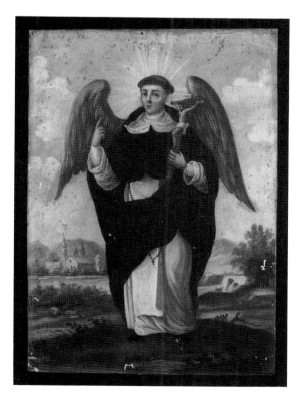

73.

EX-VOTO, 1842

7 x 5 in.
17.7 x 12.7 cm.
Roy Dowell/Lari Pitman

Afflicted with a grave illness on October 13, 1842, Don SaberIno placed himself in the care of the Lord of Chalma, who restored his health.

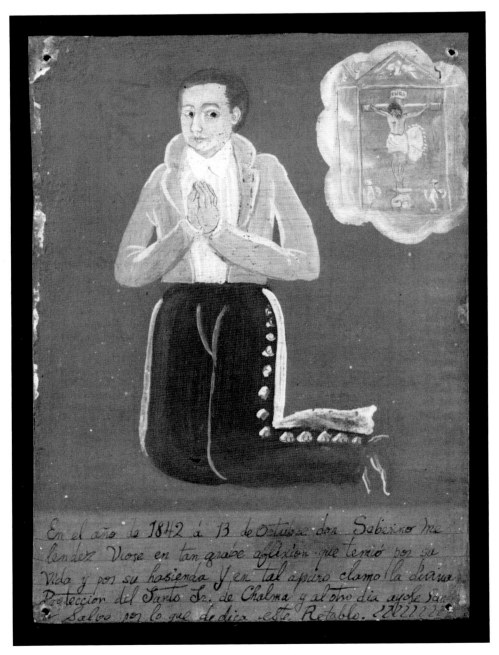

74.

En el año de 1842 á 13 de Octubre don Saberino Me
lendez Viose en tan grabe aflixion que temió por su
Vida y por su hasienda Y en tal apuro clamo la divina
Proteccion del Santo Sr. de Chalma y al otro dia aqui se
Salvo por lo que de dica este Retablo.

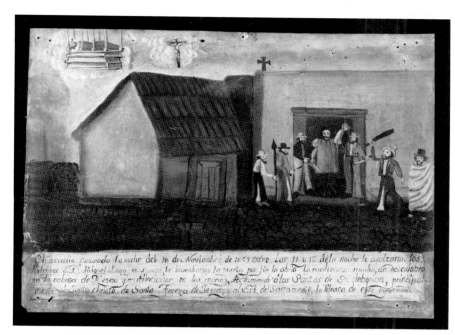

75.

75.
Ex-voto, 1855

9½ x 13½ in.
24.1 x 34.2 cm.
Private Collection

A number of men attacked this individual in his home during the night.

76.
Ex-voto, 1869

10 x 14 in.
25.4 x 35.5 cm.
Private Collection

This *ex-voto* was dedicated in gratitude that the boy Ruperto escaped injury when a mule knocked part of a stone wall onto his shoulders.

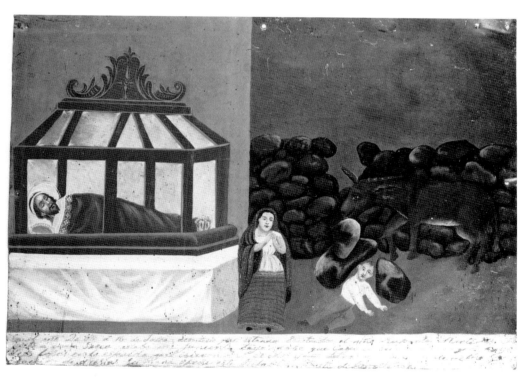

76.

77.
Ex-voto, 1873

4½ x 6 in.
11.4 x 15.2 cm.
The Mexican Museum, San Francisco

A stagecoach crashed into a water fountain.

78.
Ex-voto, 1879

6½ x 9 in.
16.5 x 22.8 cm.
Private Collection

Pedro Tobar gives thanks to the Lord of the Holy Mountain for saving him from a flood in the Chichemequillas River.

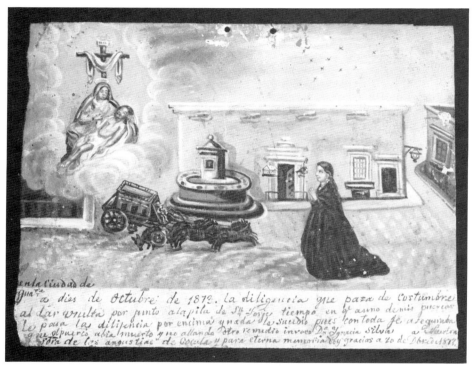

77.

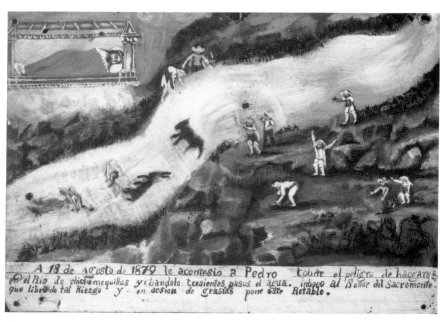

78.

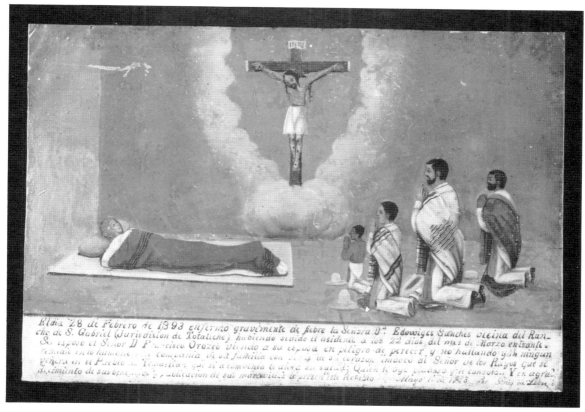

79.

79.

Ex-voto, 1893

7 x 10¼ in.
17.7 x 26.0 cm.
Kurt Stephen

Gravely ill of fever for twenty-two days, Señora Eduviges G(?) was restored to health by her husband's prayers to the Lord of Lightning.

80.

Ex-voto, 1909

9¾ x 13¾ in.
24.7 x 34.9 cm.
Private Collection

Held by her husband and another individual on the train, Señora Jesús Díaz was unable to alight safely. Because she might fall under the wheels of the train, the Child of Atocha was besought to help her.

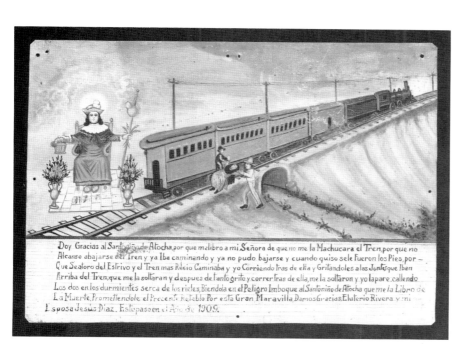

80.

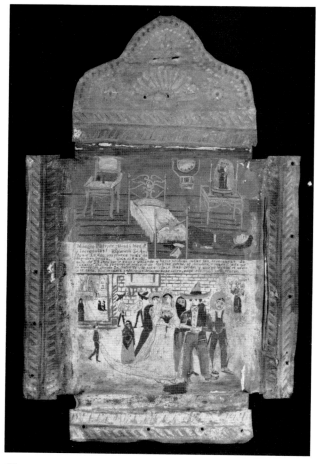

81.

81.
Ex-voto, 1910

19 x 11¾ in.
48.2 x 29.8 cm.
Joe and Rae Neumen

A desperate old maid (referred to in the text as a "little girl of 38 years old"), failing to secure a husband after saying many rosaries and performing severe disciplines, within five days after praying to San Antonio had a boyfriend and was later married.

82.
Ex-voto, 1916

10 x 14 in.
25.4 x 35.5 cm.
Roy Dowell/Lari Pittman

Juan Salazar, gravely ill of influenza, was restored to health by prayers to the Virgin of San Juan de los Lagos.

83. *See Plate XV*
Ex-voto, 1920

17½ x 14 in.
44.4 x 35.5 cm.
Calderela Antiques, Jack Calderela

Señor Miguel Hernandes was caught in a shootout between soldiers. The Holy Savior Child protected them all and with the exception of one horse being killed, no one was injured.

84. *See Plate XVI*
Ex-voto

9½ x 14 in.
24.1 x 35.5 cm.
Ron and Chris Tracy

Crossing the river from Mexico into Texas, four men were involved in a dangerous boating accident and were saved through their prayers to the Virgin of Guadalupe.

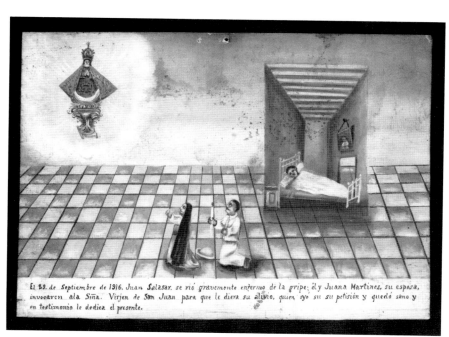

82.